DAVID NASH AT KEW GARDENS

Kew Publishing
Royal Botanic Gardens, Kew

First published in 2012 by
Royal Botanic Gardens, Kew,
Richmond, Surrey TW9 3AB, UK
www.kew.org

ISBN 978 1 84246 462 5

Distributed on behalf of the Royal Botanic Gardens, Kew in North America by the University of Chicago Press,
1427 East 60th Street, Chicago, IL 60637, USA.

British Library Cataloguing in Publication Data
A catalogue record for this book is available from the British Library.

Front cover illustration: Jeff Eden
Design, typesetting and page layout: Jeff Eden

For information or to purchase all Kew titles, please visit www.kewbooks.com or email publishing@kew.org

Kew's mission is to inspire and deliver science-based plant conservation worldwide, enhancing the quality of life.
Kew receives half of its running costs from Government through the Department for Environment, Food and Rural
Affairs (Defra). All other funding needed to support Kew's vital work comes from members, foundations, donors and
commercial activities including book sales.

Printed in Italy by Graphicom (an ISO 14001 Environmental Management System and FSC accredited company).

CONTENTS

FRONT FOLD-OUT | Exhibition Map

05 | **Welcome**
by Professor Stephen Hopper

07 | **Artist's Statement**
by David Nash

08 | **An Introduction to David Nash**
by Michelle Payne

18 | Exhibition Highlights

20 | Sculptures under Glass

32 | Wood Quarry

40 | Charred Works

42 | Bronze Works

44 | Outdoor Sculptures

74 | Sculptures in the Gallery

90 | David Nash's Life and Work

95 | Sources and Further Reading

96 | Acknowledgements and photo credits

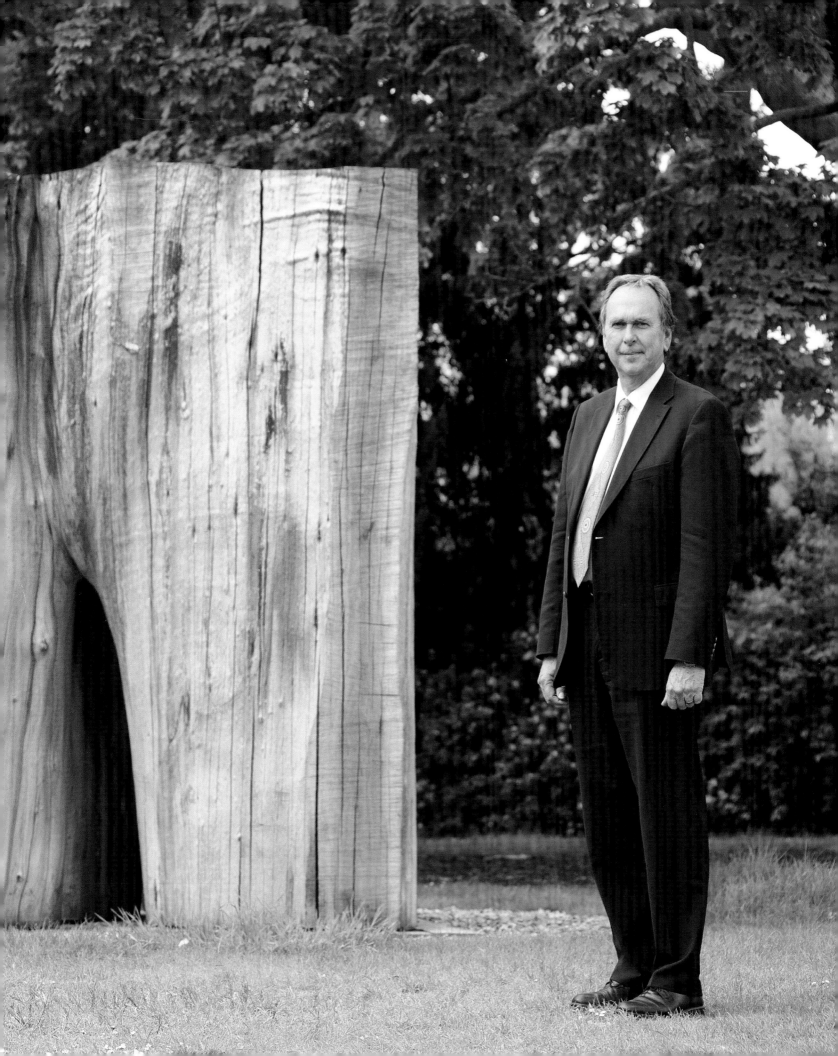

WELCOME

We are honoured to host the exhibition *David Nash at Kew: A Natural Gallery*. Nash is a significant and innovative artist, whose approach resonates with an important facet of Kew's work – to encourage people to look at plants and the natural world differently. An exhibition of this kind really helps to convey a simple but vital concept: that we are part of the web of life and nature responds to how we care for it. *David Nash at Kew: A Natural Gallery* illustrates that nature is a great source of inspiration for artists and scientists alike; this exhibition brings art and science together in a very unique way.

Professor Stephen Hopper

Director, Royal Botanic Gardens, Kew

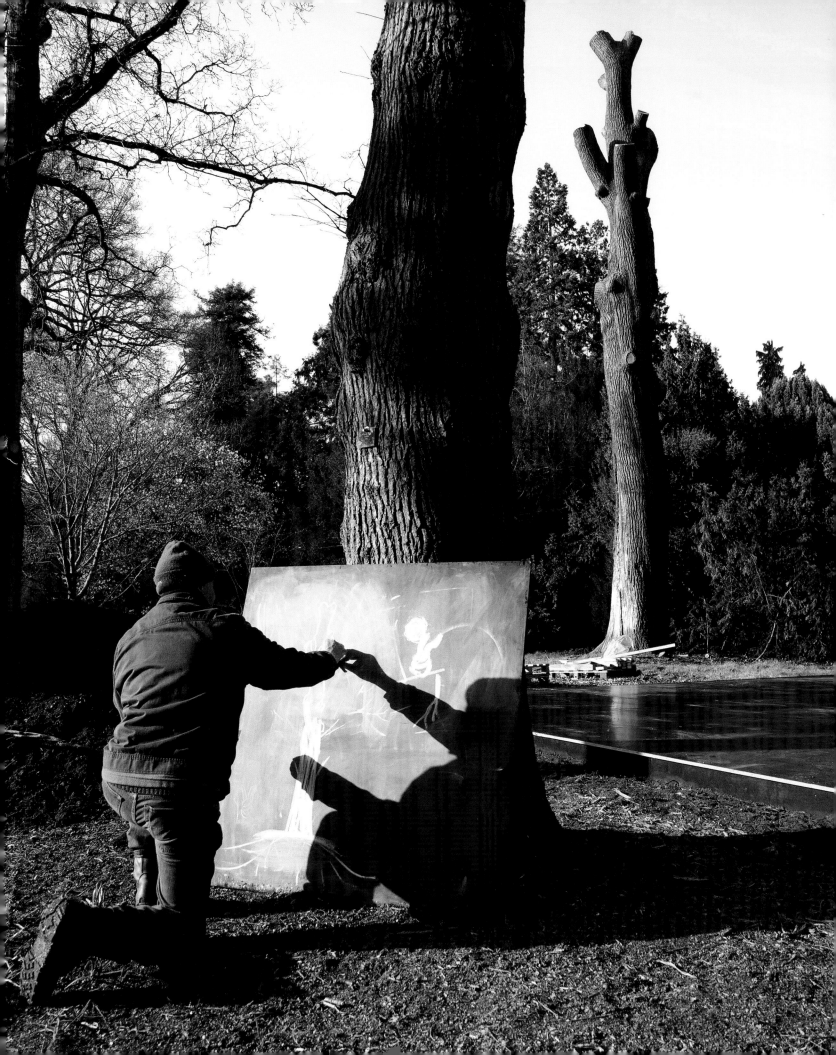

ARTIST'S STATEMENT

I am delighted that my work is being exhibited at such an iconic location as the Royal Botanic Gardens, Kew. Working within the Gardens provides me with the opportunity to continue my explorations into the science and anthropology of trees. It also provides a unique experience for visitors – you will be able to see the evolving nature of the exhibition and get an insight into the energy and processes involved in working with wood.

Every activity that takes place under the name of Kew, from saving seeds for future generations at the Millennium Seed Bank, to caring for on-site plant-based artefacts and collections, as well as the overwhelming physicality of the Gardens themselves, carries a message that reminds us that we cannot separate ourselves from the natural world. Our actions, from everyday activities to essential industrial work, have an impact on it. My work invites the same consideration. Nature is the essence of our continued existence – it guides us spiritually and takes care of us practically. Wood, specifically, is a fundamental survival material, providing us with material to build homes and with fuel to keep us warm. The art that I create is fed by such a union, and should always be observed with this essential, unique and sometimes challenging relationship in mind.

David Nash

AN INTRODUCTION TO DAVID NASH

By Michelle Payne

David Nash's latest exhibition, at the Royal Botanic Gardens, Kew (June 2012–April 2013), goes beyond showing works from his 40-year career. Far from a retrospective, this dynamic exhibition is focused on process and production.

A wood quarry – Nash's first for ten years – forms an intrinsic element, and the wood used will be sourced from Kew's tree management programme. Resulting sculptures will be added to the works already on display in the Gardens, glasshouses and galleries to produce an exhibition that evolves throughout the seasons. Drawing on Kew's and Nash's shared sympathies, *David Nash at Kew: A Natural Gallery* may inspire visitors to rethink and better understand their place in the natural world.

'The most stimulating part of this process is engaging with the space, entering into a dialogue of possibilities with what for me is like a theatre. Each space is unique, with a certain age, history and personality, and will suggest particular shapes.'

David Nash

Right: The interior of Capel Rhiw, in 2009.

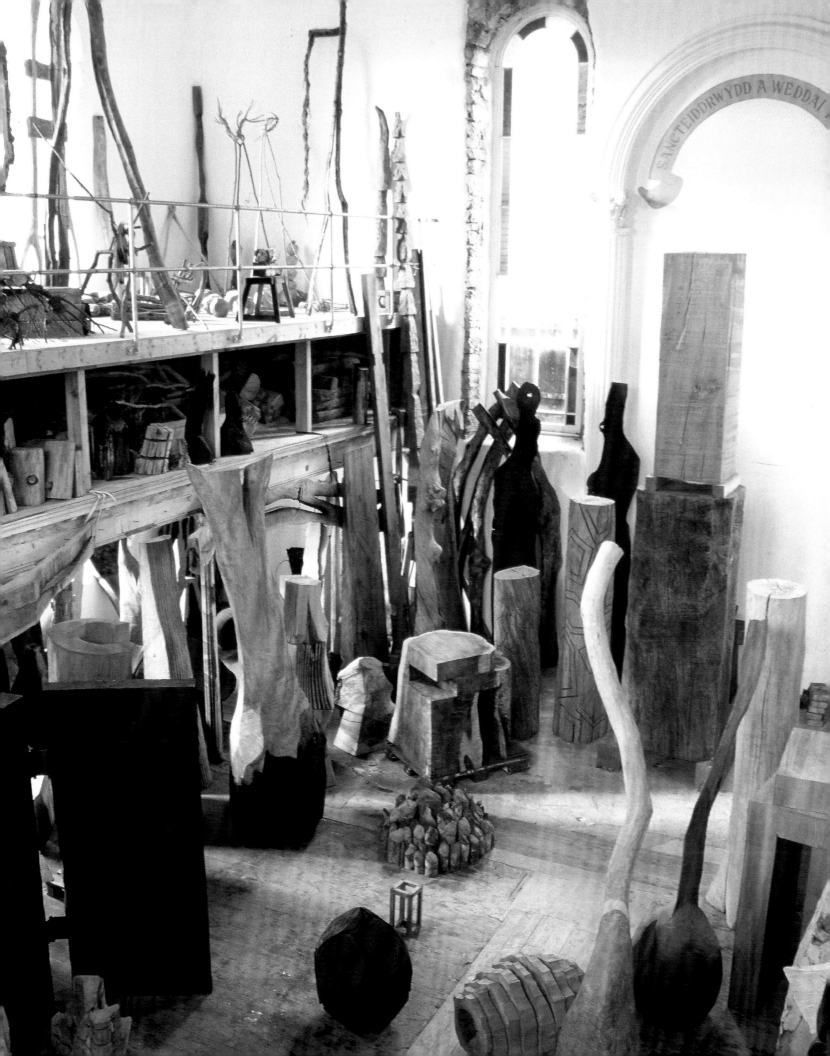

David Nash was born in Surrey but spent much of his childhood in North Wales on regular family visits to his paternal grandparents in Llan Ffestiniog. After graduating from Kingston College of Art in 1967 he moved to Wales, to the environment and landscape that, from boyhood up, worked its way into him and still informs and inspires his work today. With his 1968 purchase and subsequent conversion of Capel Rhiw, a disused Methodist Chapel and outbuildings in Blaenau Ffestiniog, Nash began putting down roots in the land. Today, Capel Rhiw is still home to the Nash family.

Visits to Constantin Brancusi's Paris studio informed Nash's transformation of Capel Rhiw into connected living and work spaces; a fusion characteristic of Nash's unified approach to art and life. Over the years additional work and storage space have been added as necessary and today the chapel is used primarily for storage and display. The wide open space of the ground level (with its recently re-enforced floor) is perfect for storing large sculptures, and the overall effect is dramatic, as light streams down from the high stained-glass rimmed windows, bringing the sculptures to life. When viewed from the gallery level above – home to smaller sculptural forms – the large pieces below form an intriguing tableau, inviting the viewer to engage with them, both individually and in juxtaposition.

Capel Rhiw in 1974,
dominated by vast slate tips.

First Tower (1967– 68),
situated on a rocky
Blaenau hillside.

CULTIVATING INFLUENCES

'The new congregation' is the name given to the works that Nash has decided to keep for public exhibitions, highly appropriate for a collection residing in a chapel under the inscription *Eiddiwydd a weddai i'th dy* (sanctify this house with prayer). But these religious connotations should not suggest that Nash is consciously evoking Christian language and concepts – this cultural influence is subliminal, not overt. While his works reflect and embody the range of his philosophical and spiritual influences, these cannot be separated from formal artistic concerns: influences filter, overlap and feed into one another, finding their final single expression in the creation of sculpture.

Seen as a whole, Nash's work forms an extended comment on humanity's relationship with nature, advocating a direct, simple connection between man and world. He is uncomfortable with the term 'nature', feeling it denotes a sense of being 'over there', separate and apart from humanity and human concerns. In interviews he has spoken of landscape painting, and of how 100 years ago artists such as himself, Richard Long and Hamish Fulton would probably have been painters of landscape, producing paintings of what is conceived to be outside of and separate from the artist. In contrast to this, the impulse of these artists is to be *in* the landscape itself, not representing from 'outside'.[1] Instead of 'nature', he favours discussion of the environment, or elemental forces: terms that allude to the fundamental role natural forces play in humanity's continued existence.

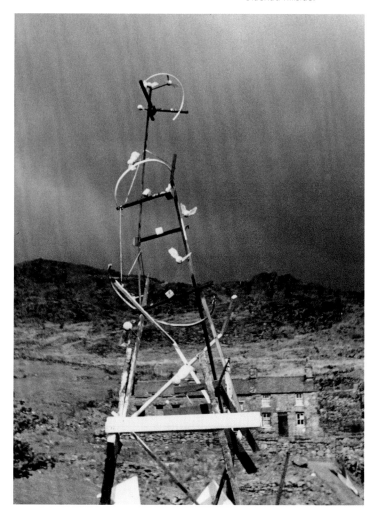

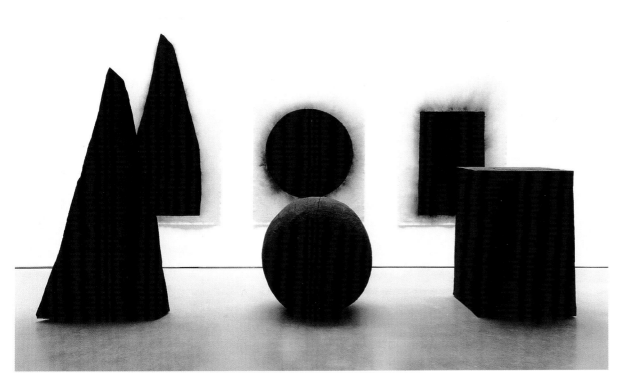

Overleaf: *Family Tree* (1994) began as a three-panel work depicting the main branches of Nash's work, together with their interconnections, all springing from the first tower in Blaenau Ffestiniog.

Pyramid Sphere Cube (1997), charred oak and canvas.

He talks of the environment as our 'outer skin', a term that evokes our connection with and dependence on it. We are in and of the environment, not apart from it or its master. Everything we do impacts on it, for better or for worse.

This understanding is in line with principles from Buddhism, Taoism and Steiner's Anthroposophy that inform Nash's thinking. Values of connection, balance, appropriateness and simplicity inform his creative process and are expressed through his work. Simplicity, for example, can be seen in his decision to use wood as his primary material – a natural product, of which he had an easily accessible, ready supply. Simplicity then feeds into technique, with Nash working the material just enough for the form to show itself, no more. You can chart Nash's career through this move away from complex forms towards simplicity and economy; it shows the artist's developing awareness of his innate style and his growing knowledge of and trust in his own process.

[1] Susan Daniel-McElroy, 'Interview with David Nash', in *David Nash: Making and Placing*

'FAMILY' CONNECTIONS

The *Family Tree* works provide a graphic illustration of this development over time and demonstrate the different branches of and interconnections between Nash's sculptures. This original three-panel version includes developments up to 1994. One *Family Tree* drawing, from 1996, forms a vertical rather than horizontal tree, and places emphasis on the geometric forms – in particular the pyramid, cube and sphere – which form an important strand of Nash's work. In the year 2000 a fourth panel was created to bring the *Family Tree* up to date, and again in 2008. Throughout the Kew exhibition, the five-panel version will be on display in the Shirley Sherwood Gallery of Botanical Art at Kew.

One of the most interesting aspects of the *Family Tree* drawings is their confirmation of various themes and impulses that divide Nash's output into discrete strands. We see how forms and concepts are broken down, separated, then developed, repeated, varied. Works of art in themselves, the *Family Tree* drawings are also a visual appraisal and analysis of the work to date, an evaluation by the artist himself.

Nash's first major sculpture, *First Tower* (1967–68), marks the start of the *Family Tree* works. This elaborate structure, built on one of Blaenau's rocky hillsides, was 8 metres tall, painted with primary colours ascending from reds to blue, and constructed from wood that Nash had salvaged from demolition sites. The tower led the way to *Broken Archway* (1968–69), although further towers followed during his year back in London, studying at postgraduate level at Chelsea Art College. A marked change in approach can be seen in the Chelsea Towers, from the wild Dadaist-flavoured *Chelsea Tower I* to the tightly constrained form of *Chelsea Tower III*. Today, the importance of the towers stands in their being the single source from which all subsequent strands of thought and expression flowed; like a seed they were full of energy and potential that grew and developed over time.

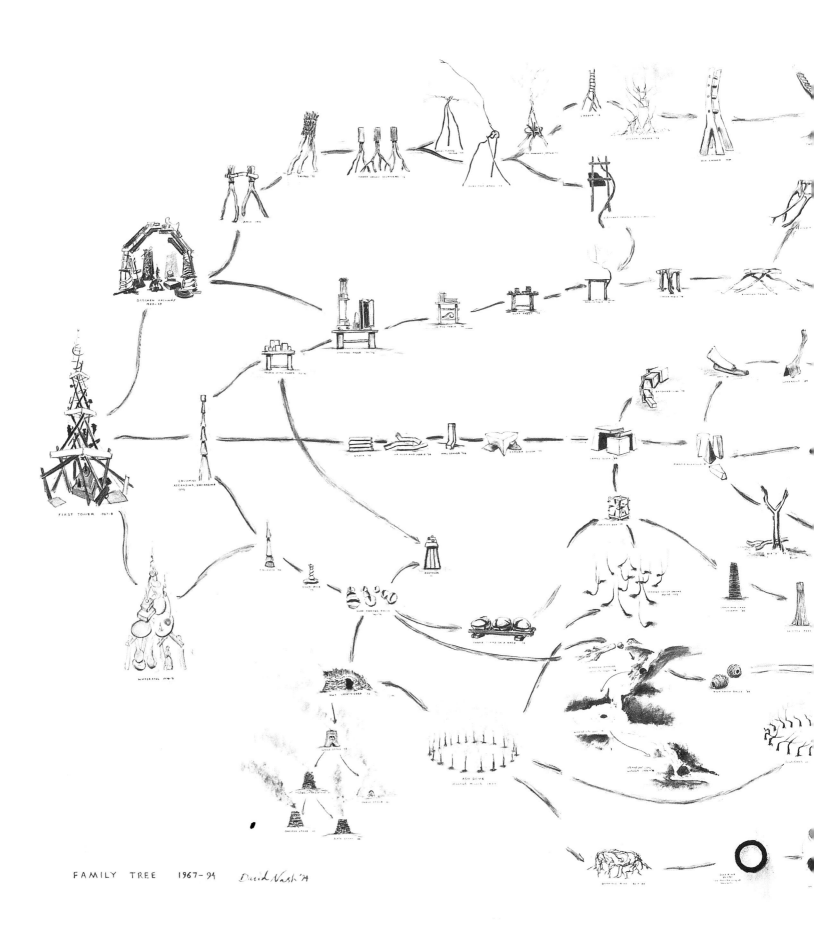

FAMILY TREE 1967-94 David Nash '94

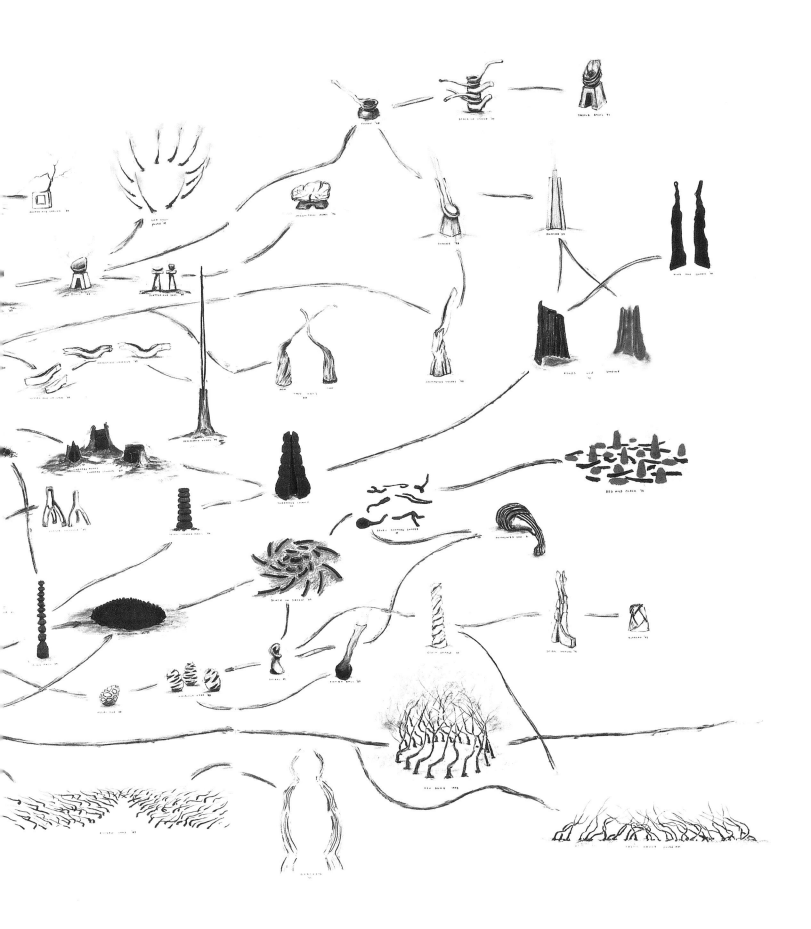

QUARRYING FOR FORMS

Working with wood made available naturally (for example as a result of storms, lightning or disease) Nash excavates trees in what he calls a 'wood quarry'. Indicative of the sheer physical effort of working with a whole tree, Nash's term also evokes a sense of drawing on something pre-existent. To establish momentum, Nash starts the quarry by producing a known form. For this and subsequent pieces, he looks to the species' characteristics and the individual specimen he is working with to gain inspiration and guidance from the material itself; then he shapes and adapts his original vision in response. After a few days, ideas begin to flow freely.

The first wood quarry was in Nash's home territory, at Maentwrog in the Ffestiniog Valley. Over a two-year period, starting in 1978, the tree yielded eight sculptures, including the *Wooden Boulder*. His first major international wood quarry was in Japan, in 1982, working with a team of skilled Japanese woodmen. With no common verbal language, they understood each other through their shared knowledge of trees and wood, they both spoke 'wood' fluently. So positive was this new collaborative form of work that it became Nash's main working method throughout the 1980s and 1990s. During this period Nash conducted wood quarries in many countries, including Japan, the Netherlands, France, Spain and North America, producing exhibits brought to life *in situ* and resonating

with deep sympathy for their unique place and setting. The sense of community goodwill that arises during such collaborative efforts is essential to the overall success of the project: as Nash says, 'If the human spirit is withdrawn, then all I have is a load of heavy, dormant lumps of wood.'[2]

When conducting a wood quarry, Nash looks to the tree to see what forms the shape and nature of the individual specimen suggests. An early example of this responsive practice can be seen in *Twenty Days with an Elm* (1982), which shows the elm marked with cut lines like a butcher's diagram, with the resulting shapes alongside. Here, the V of the dividing branches inspired the theme of *Pyramids and Catapults*. These shapes themselves point towards two significant themes in Nash's work: the catapults suggestive of the works that explore human tools (for example the tables, bowls, spoons, thrones and shrines signifying domestic and ceremonial or ritualistic uses); and the pyramids of Nash's abiding interest in geometric universal forms.

The sequence *Pyramid Sphere Cube* recurs throughout Nash's work, as both individual shapes and together. He has created many variations, with the shapes arranged in one row or on different levels, charred, partially charred, incised, set in front of their two-dimensional equivalents. In the 2012 Kew exhibition, these forms (cast in bronze) can be seen set among tree ferns in the Temperate House, the black universal forms contrasting with the simple, organic trunk shapes.

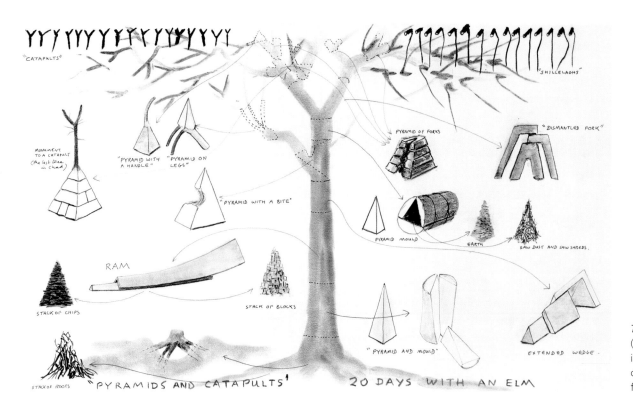

Twenty Days with an Elm (1982) – this early work illustrates Nash's method of looking to the material for a starting point.

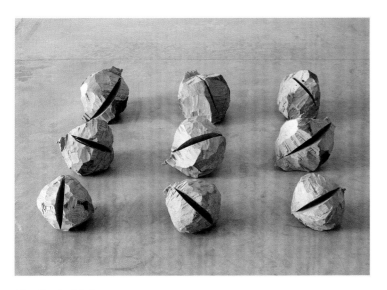

Nine Cracked Balls
(1970–71), ash.

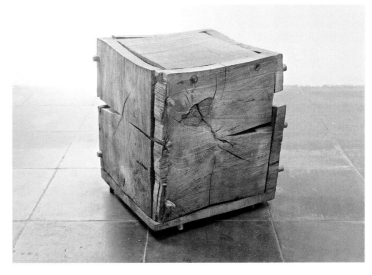

Cracking Box (1979),
oak.

Placing – Going (1989),
charcoal on paper.

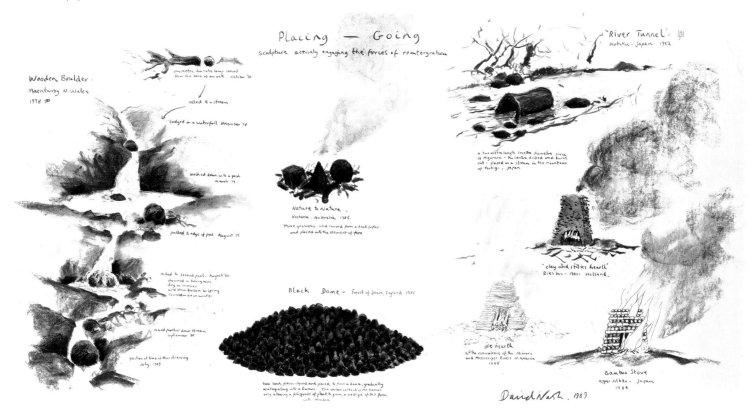

The first *Pyramid Sphere Cube* was produced by Nash in Japan, during 1984. His interest in these shapes reaches back to a childhood enthusiasm for geometry, later reignited by drawing lessons with a teacher who encouraged him to follow Cezanne's method of observing these pure forms in the landscape. These simple shapes occur and recur throughout the man-made and natural world, and we humans appear innately tuned to recognise them. Nash's home in Blaenau is situated at the foot of one of the town's towering slate tips. And living beside the horizontal and diagonal lines of slate, while focused on making cuts into another material, wood, has caused Nash to sense these geometric forms deeply within. He recognises the forms in the natural world, he senses them in the wood and he gives expression to them in the forms he creates.

[2] David Nash, quoted in *David Nash*, page 93 (Thames & Hudson)

THE LANGUAGE OF WOOD

Nash equates his ever-growing knowledge of, and intimacy with, his chosen material to learning to speak a second language, the language of wood. Just as communication is a two-sided process, learning the language of wood involves both listening and responding. When Nash first began working with wood he used milled building timber, but this, he says, was dumb wood – it had no story, no history. A palpable sense of story can be seen not only in works such as *Ancient Table* (1983), which was made with ancient beams from a derelict 18th-century barn, but in the many pieces that use woods local to the area where the work is produced. One such piece is the *Mizunara Bowl* (1994), made in Japan from mizunara wood, a type of Japanese oak. The story behind his material, where it comes from and how it is sourced, is of the utmost importance to Nash on several levels: ethically, for environmental reasons, and practically for the way it guides and limits his working process. For example, while working on a project in Hokkaido, Japan, he noticed that the large elm he had been given to work had some deep decay in one side. By carving the pieces and then purging the rotten

areas with fire, Nash created an effect akin to forms within forms – charred shapes within geometrically carved forms.

Now fluent in the language of wood, Nash is able to comment with ease on differing species' characteristics. Oak, he says, is heavy and resistant to carving, whereas lime has a balance of give and resistance that makes it an ideal carving wood. The differing ways species change (drying, warping, changing colour) when cut and exposed to air is vividly illustrated in his ever-growing series of *Crack and Warp* columns. A selection of these will be displayed in Kew's Nash Conservatory from October 2012 until the end of the exhibition.

Nash is known for using motorised tools such as chainsaws for creating his large-scale works, but for the first ten years of his career he worked exclusively with hand tools. Without this apprenticeship, working closely with the wood on a small, intimate scale, he would not have gained the detailed knowledge of his material so essential to his practice. Early works such as *Nine Cracked Balls* (1970–71) were important steps along the path. The prominent cracks in these balls were a result of the wood's exposure to air over several months; they were not made by the artist's hand. On first observing the cracks Nash felt the balls were grinning at him and he accepted, if not embraced, their nature, going on to produce associated works such as *Cracking Box* (1979) and the many *Crack and Warp* columns. These later *non-finito* works, where the elements take over when the artist stops, not only illustrate Nash's growing fluency with the language of wood, they also point towards the way his work can be seen as the meeting point between human consciousness and will, and elemental forces. They are an expression of his multi-faceted collaboration with nature.

GROWING AND (GOING)

The *Growing* works at Cae'n-y-Coed, epitomised by *Ash Dome*, are a prime example of this collaboration. *Ash Dome* is a circle of 22 ash trees planted at 2 metre intervals that have been grafted and pruned to form a dome. Listening to Nash speak, the deeply responsive element of his process is apparent. The trees respond

'I want a simple approach to living and doing. I want a life and work that reflects the balance and continuity of nature. Identifying with the time and energy of the tree and with its mortality, I find myself drawn deeper into the joys and blows of nature. Worn down and regenerated; broken off and reunited; a dormant faith revived in the new growth of old wood.'

David Nash

to Nash's husbandry and interventions and he, in turn, adapts his actions depending on their response. The *Ash Dome* is a 34-year (and continuing) dialogue between Nash and the living, growing, responding ash trees.

Another type of collaboration can be seen in the *Going* works, of which the ultimate is the *Wooden Boulder*. This radical work is the clearest expression of a thread that runs at a more subtle level through much of Nash's work: the realignment of the artist's role in relation to his work. The genesis of this work shows Nash's adaptability. Working on an oak tree on the hillside where it had grown, he needed a way to transport a roughly carved sphere to the valley lane below and hit upon the idea of using the stream to manoeuvre the boulder downstream. The boulder was rolled into the stream, but halfway down a waterfall became firmly lodged. At this point, Nash reformulated his vision to focus on the potentials of the situation he now found himself him. Instead of being the creator of a finished

form, Nash became the work's catalyst, with the shaping being continued by elemental forces (water, rain, sun, wind). And from being a catalyst, the artist moves to becoming a witness, or to use writer Roger Deakin's term, a 'biographer, recording the story of the boulder's physical evolution … and its journey through stream, river and – possibly – sea.'[3]

These two examples of *Ash Dome* and *Wooden Boulder* could be viewed as each other's inverse: whereas *Ash Dome* grows into being through careful nurture, *Wooden Boulder* moves away and can only be documented from a distance. However, on another level they can both be seen as not only comments on but, as naturalist Richard Mabey suggests, a metaphor illustrating the kind of relationship humans should have with the natural world.[4]

[3] Roger Deakin, 'David Nash', in *Wild Wood*

[4] Richard Mabey, 'David Nash's Artistic Estate' (1997), in *Selected Writings 1974–1999*

Ash Dome (1995),
pastel on paper.

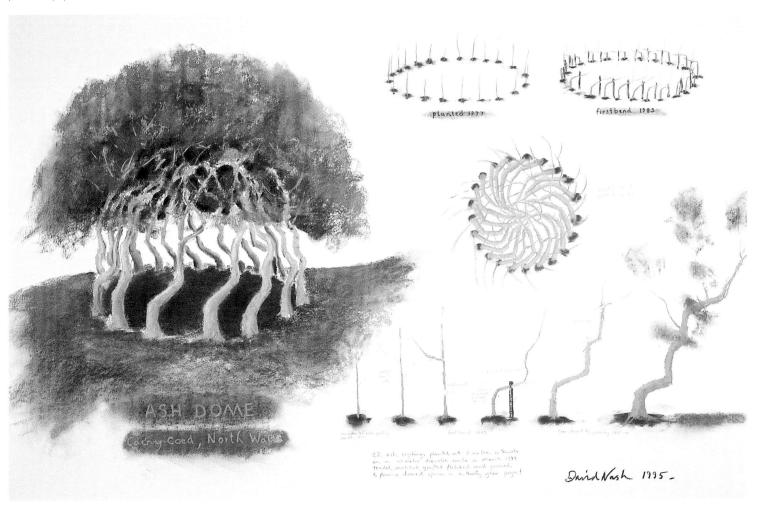

EXHIBITION HIGHLIGHTS

David Nash – A Natural Gallery is an exhibition with the creation of new works at its heart. Sculptures, drawings and film installations are on display throughout the Gardens, in the glasshouses, and the Shirley Sherwood Gallery of Botanical Art. The exhibition runs from June 2012 through to April 2013, with additional works and display settings refreshing the exhibition in October 2012.

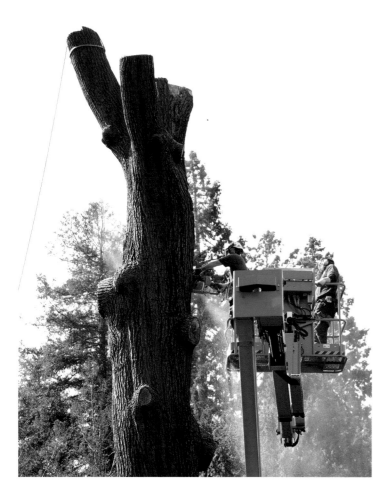

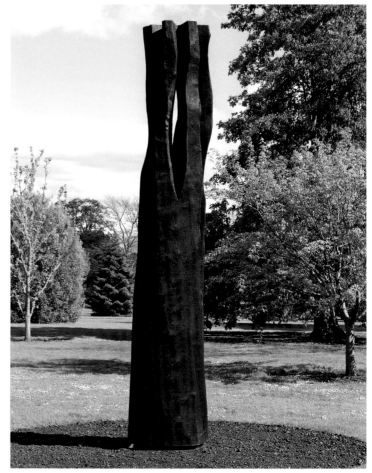

The Wood Quarry will be worked by David Nash and his team from April to September 2012. Visitors will be able to see sculptures taking shape, and finished forms will be displayed *in situ* before relocation to other parts of the Gardens. Volunteers will be on hand to answer visitors' questions and a blackboard illustrating the day's work plan will be available for view. See pages 32–39 for further information on Nash's wood quarries.

Outdoor sculptures will be situated throughout the Gardens, including two new pieces *Cairn Column* and *Flame Column* as well as a major new installation entitled *Cork Dome*. Works produced in the Wood Quarry will be re-sited in the Gardens in October 2012. For more on the outdoor sculptures see pages 44–73, and for their locations please refer to the front fold-out map.

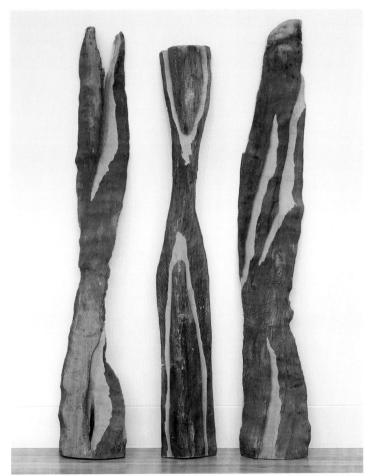

Sculptures Under Glass can be viewed in the Temperate House for the entire exhibition period. Wood and bronze sculptures will be situated alongside, and among, the plant beds of the central section, interacting with the shape and colour of the surrounding plants and the architectural lines and space of this historic glasshouse. In October 2012 the Nash Conservatory will join in the show, displaying sculptures in sympathy, or juxtaposition with, the architectural structure of the Conservatory.

Gallery works will be on show in the Shirley Sherwood Gallery of Botanical Art for the entire exhibition period. A tableau of sculptures will fill the gallery's main space. New drawings of Kew trees will be displayed along with a range of other wall works. Key Nash works such as *Ash Dome, Blue Ring* and *Wooden Boulder* will be represented through video installations, photos and drawings and the *Family Tree* drawings can be viewed from the reception area. For more, see pages 74–89.

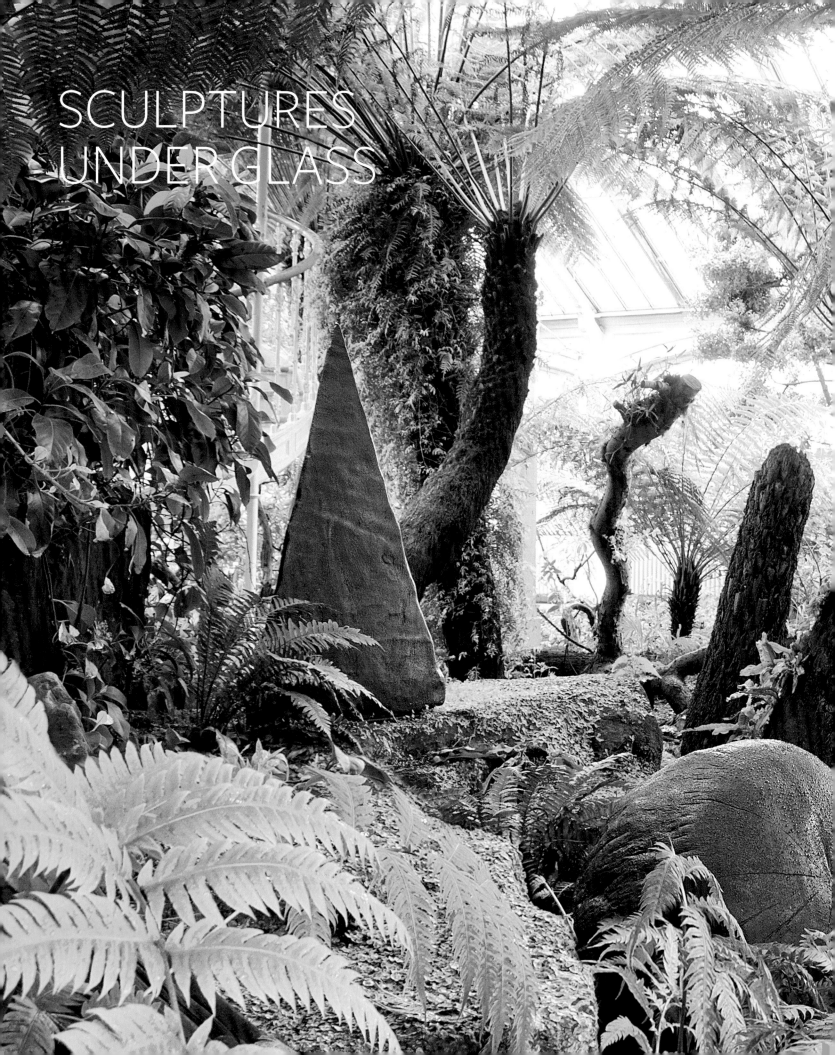

SCULPTURES
UNDER GLASS

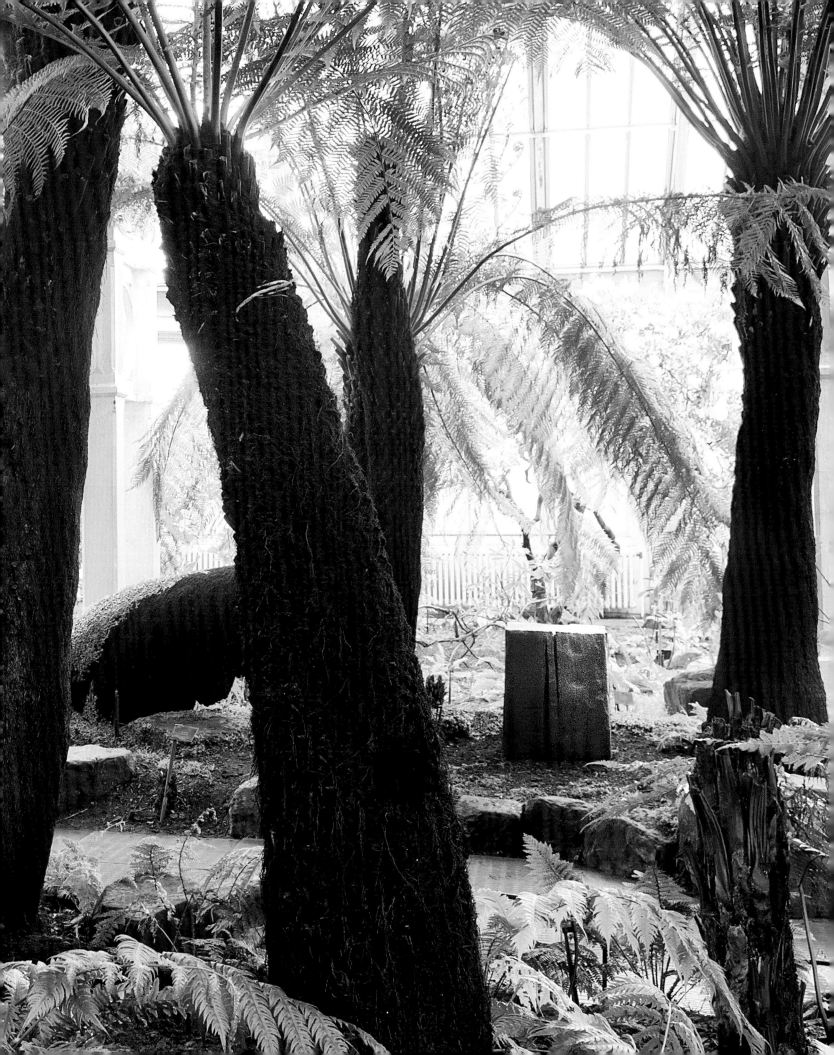

THE TEMPERATE HOUSE

The solid, inviting form of *Mizunara Bowl* is sited at the central entrance of the Temperate House. It was sculpted in Japan in early 1994, as part of Nash's *Spirit of Three Seasons* project and is made from mizunara wood, a Japanese oak with a particularly high moisture content – *mizu* means water in Japanese. Nash has cut the bowl from the largest part of a robust trunk; the palest parts are sapwood, the darker parts heartwood. Its open bowl faces into the space, beckoning visitors to enter and explore, and guiding eyes up the pathway to the stately *Throne* (illustrated on page 26), which presides over the central crossways, its pale beech wood contrasting with the vibrant green of surrounding vegetation.

Many of Nash's sculptures allude to man's dependence on nature – and specifically wood – for basic survival tools and utensils.

The bowl shape is one example; another is ladders and steps, represented here by *Apple Jacob* (illustrated on page 25) and *Napa Ladders*. These works suggest reach and expansion, and juxtapose with pieces like *Seed* – a contained ball with potential to roll, move, or, as a seed, to grow. *Comet Ball* combines these forms, the charred ball at the base grounds the form, but the eye wanders upwards along the uncharred tail, reaching towards the sky. Another domestic form, a table, is suggested in *Plateau*, the block forming a special resting place for the three universal forms, enabling the eye to look directly onto and across the *Cube Pyramid Sphere* grouping. A bronze cube, sphere, pyramid grouping is also on display among the Temperate House tree ferns, where their geometric shapes interact with the organic growth patterns of the black trunks (illustrated on pages 20–21).

Previous page:
Cube Sphere Pyramid (2010), bronze.

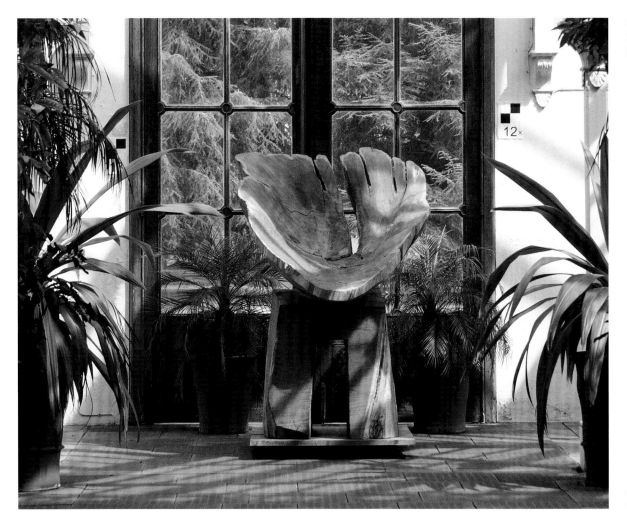

Mizunara Bowl (1994), mizunara.

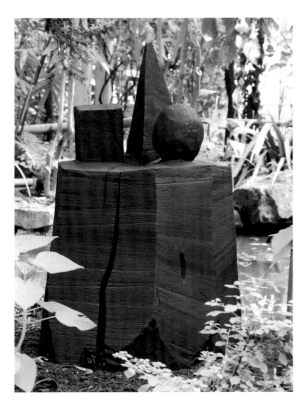

Plateau (2011), bronze.

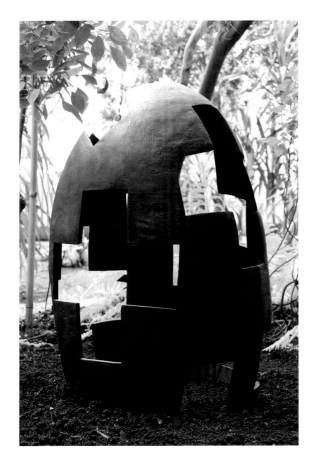

Crossed Egg (2002), bronze.

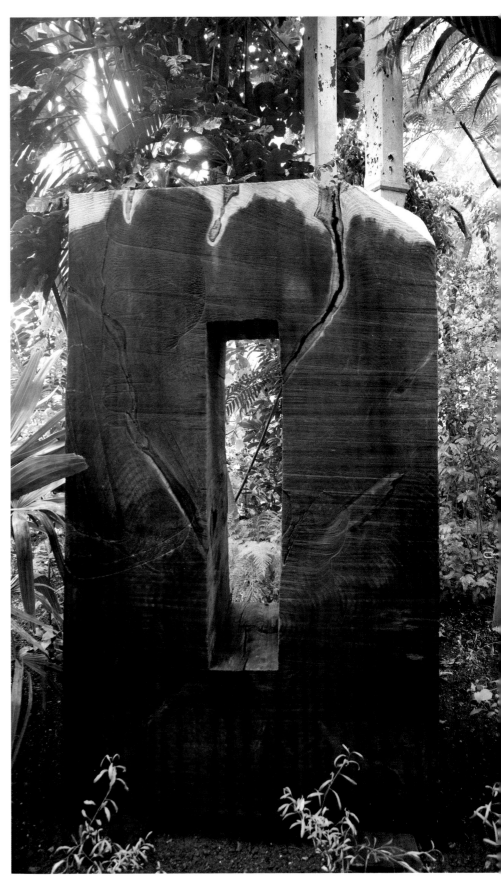

Red Frame (2008), redwood.

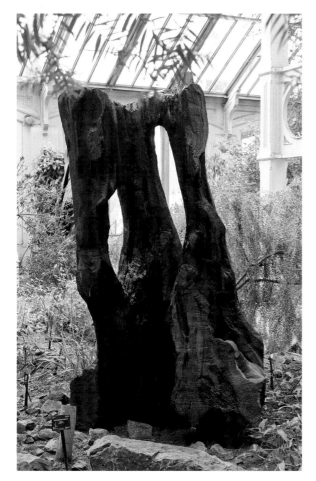

Cave (2007),
partly charred yew.

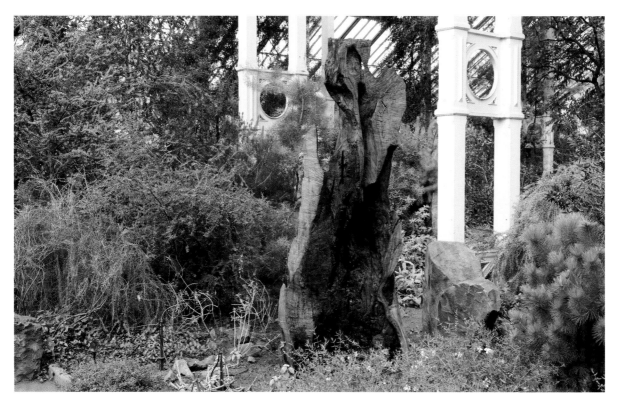

Crag (2007),
partly charred yew.

Near the slender centre-piece *Throne* sits the characterful *Big Tongue*, lolling out from tripod legs. Created as part of Nash's *Chêne et Frêne* project in 1988, *Big Tongue* is now one of the Capel Rhiw congregation. Tripods are a form Nash has been exploring since the 1970s. *Apple Jacob,* in which tripod legs support the stairway torso that extends itself step by step, is another example of this interest.

Crag and *Cave* appear absolutely in harmony with the Temperate House surroundings, their natural red tint corresponding with the red earth on which they rest. These partly charred works are made from an ancient yew tree, possibly as old as 1,500 years, which Nash found lying neglected in a wood yard. He charred the centre to burn out rot, which left a cylinder from which *Crag* and *Cave* were carved. The energy between red and black, seen here in the yew's rich red hue and the char's blackness, is a dynamism Nash has explored through both sculptures and drawings. Another example of this on show in the Temperate House is *Red and Black Dome* (illustrated on page 29). Rather than painting his works, Nash plays with the natural hues of the wood, drawing on his knowledge of how the colours change and deepen as the wood dries, sometimes accentuating these through contrast with black charring.

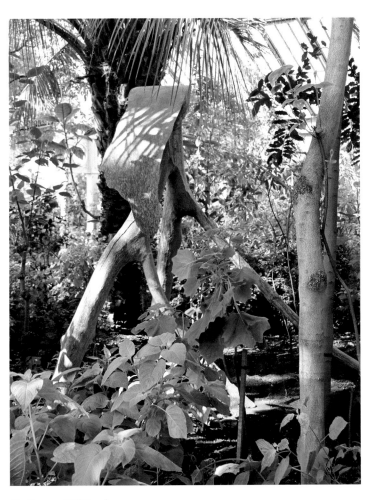

Big Tongue (1988), ash.

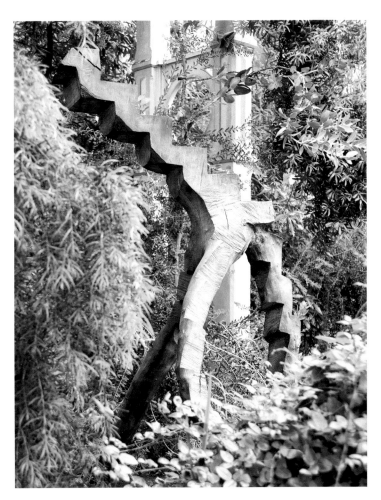

Apple Jacob (2009), bronze.

'My early sculpture was about putting colour into space. Wood was a useful support for the colour. Gradually I came to feel dissatisfied with the colour being only a skin. I tried staining the wood in colour to give it physical depth. Eventually, when I started working with natural, unseasoned wood, I accepted its natural colour as a given.'

David Nash

'Unlike the triangle, circle and square, which are universals with a sense of completeness, the cross is an unresolved sign with many uses – from marking a place on a map, denoting error, multiplication and addition, to being a flag emblem or a religious symbol.'

David Nash

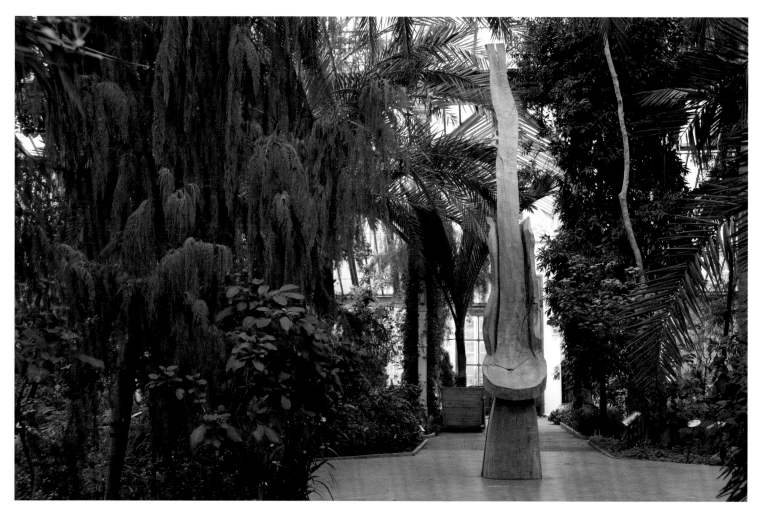

Throne (1991), beech.

Up the central path from the slender centre-piece *Throne* sits another of Nash's characteristic forms, a *Crack and Warp* column. This column is lime wood, cut in 2010. *Crack and Warp* columns are a form of sculpture made possible by Nash's use of chainsaws and his knowledge of how different species react to the drying process. When freshly felled, wood has a high moisture content, but when exposed to air this water evaporates and the wood shrinks, resulting in cracks and warps. Only certain woods have the right qualities for *Crack and Warp* columns. Some, such as the redwood, from which *Red Frame* is made, do not crack through the drying process. *Red Frame* further juxtaposes with the *Crack and Warp* column by its

shape and weight, and by the colour contrast between its blonde sapwood and red heartwood.

Contrasting in both form and nature with the lofty and light *Crack and Warp* column is the bronze *Crossed Egg*. The egg is a pure, simple form, one that, like seeds, is full of potential and energy. In this piece, these associations combine with others suggested through Nash's use of the cross shape, taking away from the egg form by cutting crosses out of it. The cross is a loaded sign with multiple meanings, but whereas many people think first of its religious associations, Nash is predominantly interested in its secular uses and meanings.

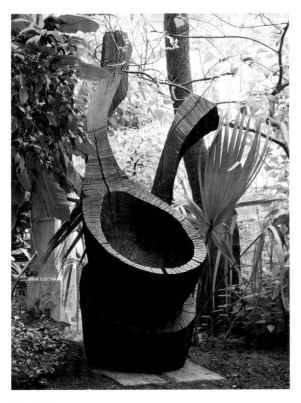

Two Falling Spoons
(2006), bronze.

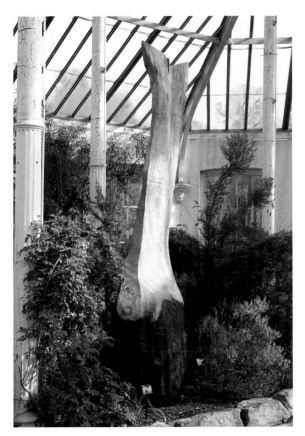

Comet Ball (1995),
partly charred elm.

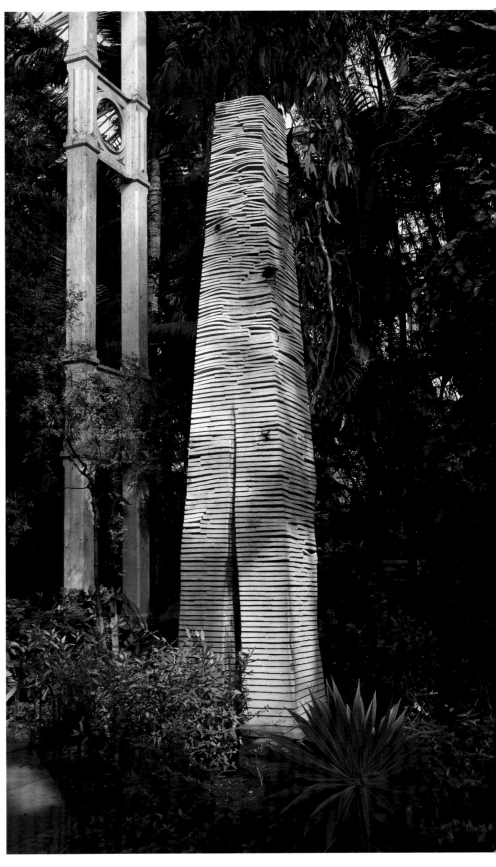

Crack and Warp (2010), lime.

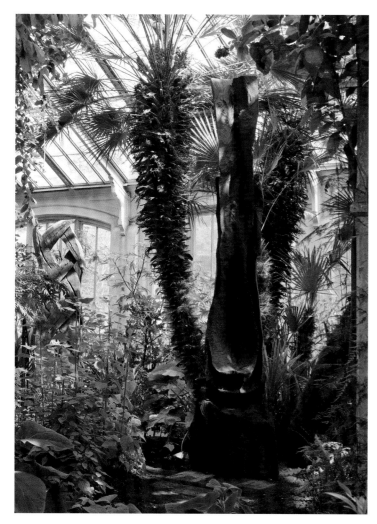

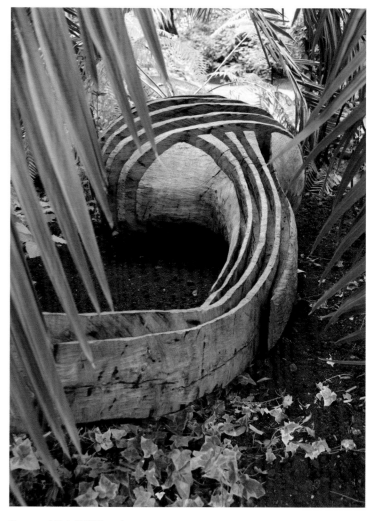

Red Throne (2012), bronze.

Furrowed Oak (1991), oak.

Along from *Red and Black Dome* sits a piece at rest, low down among the plants. This is *Furrowed Oak*. Its form – a ball shape growing into an extended limb – is reminiscent of *Comet Ball*, but with an impression of length rather than height. Its length and the base-width are accentuated by deep cuts, the 'furrows' to which its name refers. A very different cutting effect can be seen in *Overlap*, in which intricate cuts and levels have been created that combine to give a striking impression of woven wood.

Red Throne and *Two Falling Spoons* are two of several bronze works on display in the Temperate House. Both had wood predecessors: *Red Throne* in a throne carved from yew in 1989; *Two Falling Spoons* in charred oak, from 1994. Working with metals, mostly bronze but also iron and steel, is a relatively recent development for Nash. On a purely practical level it enables him to create works that will endure, and display them outdoors or in damp environments such as particular zones inside Kew's Temperate House. At a deeper level, it extends his understanding of working with the elements.

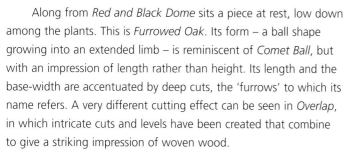

'I have come to understand that the element "earth" means everything that has matter, molecules; "water" means movement and time; "fire" means light, heat; "air" means space… Take cold metal (earth), apply heat (fire) to it to make it molten and fluid (water), pour it into a mould (air), remove the heat and the metal reverts back to an earth state.'

David Nash

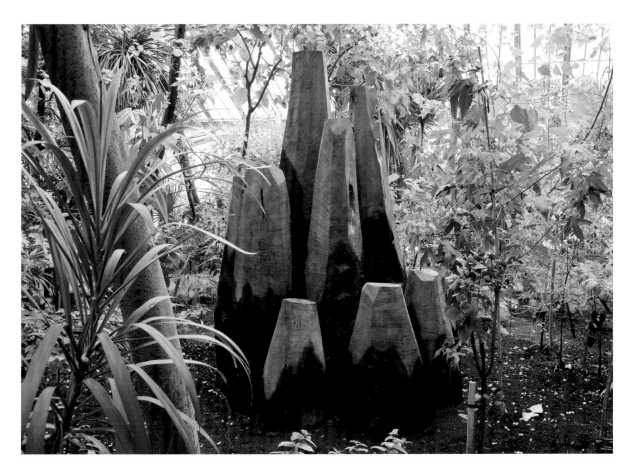

Red and Black Dome (2006), partly charred yew.

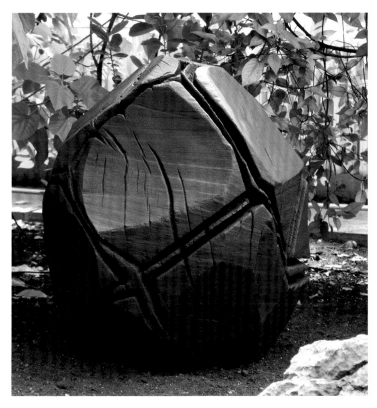

Seed (2007), bronze.

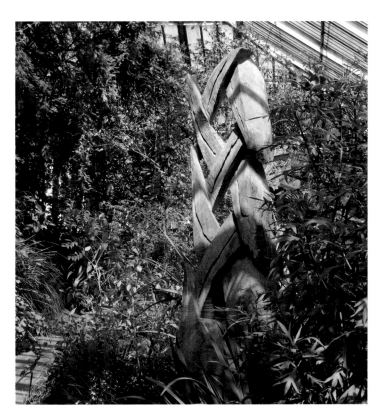

Overlap (1994), elm.

THE PRINCESS OF WALES CONSERVATORY

Three Iron Humps and *Oculus Slab* are both closely-connected to other works in the exhibition at Kew. The shape of the individual pieces of *Three Iron Humps* suggest the work's affinity to *Iron Dome* but the colour and surface texture separates the two sculptures. The difference in appearance is a result of the *Three Iron Humps* being sand-blasted before being allowed to develop a rust patina.

Oculus Slab is, as its name suggests, an offcut from *Oculus Block*. Whereas *Oculus Block* speaks of the sheer density and weight of eucalyptus, in *Oculus Slab* the wonderful outline created by the fusing of four eucalyptus trunks is most evident, along with the 'oculus' eye and the lines, cracks and natural variation of hues in the wood.

Three Iron Humps (2009), cast iron.

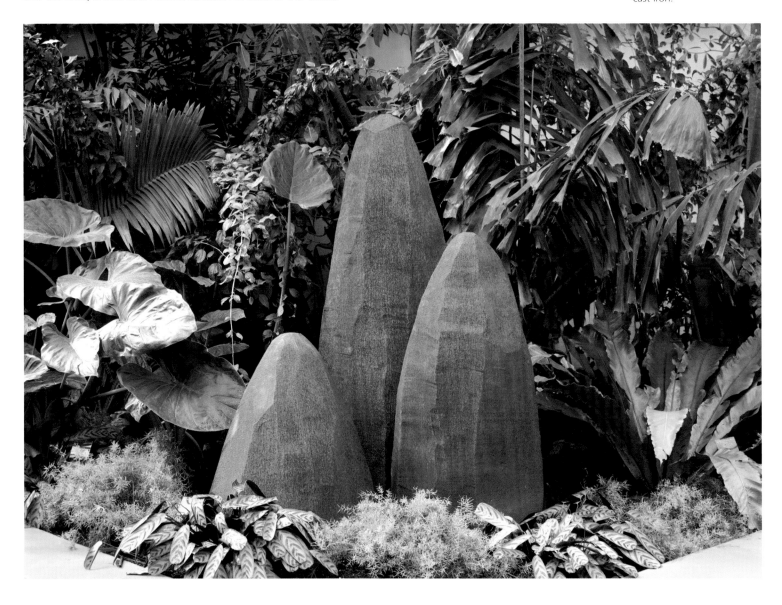

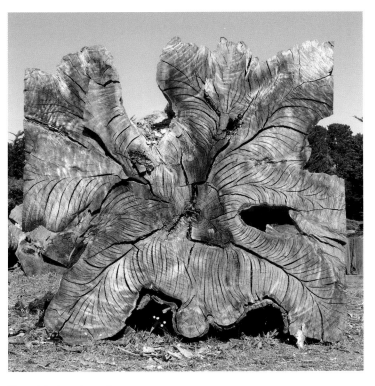

The original cracks and colours in *Oculus Slab*.

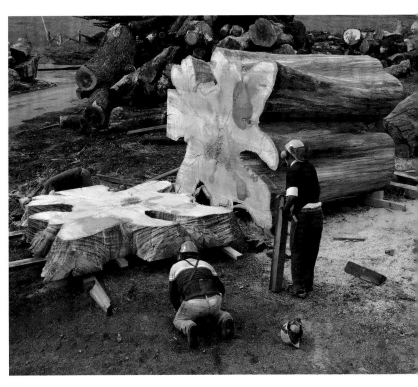

Oculus Slab freshly cut from the block.

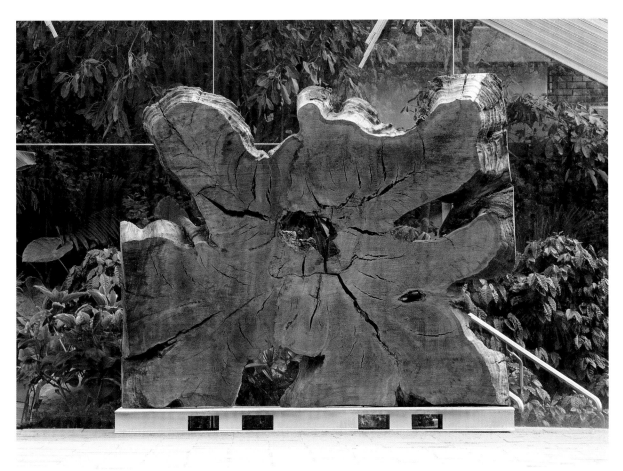

Oculus Slab (2010), eucalyptus.

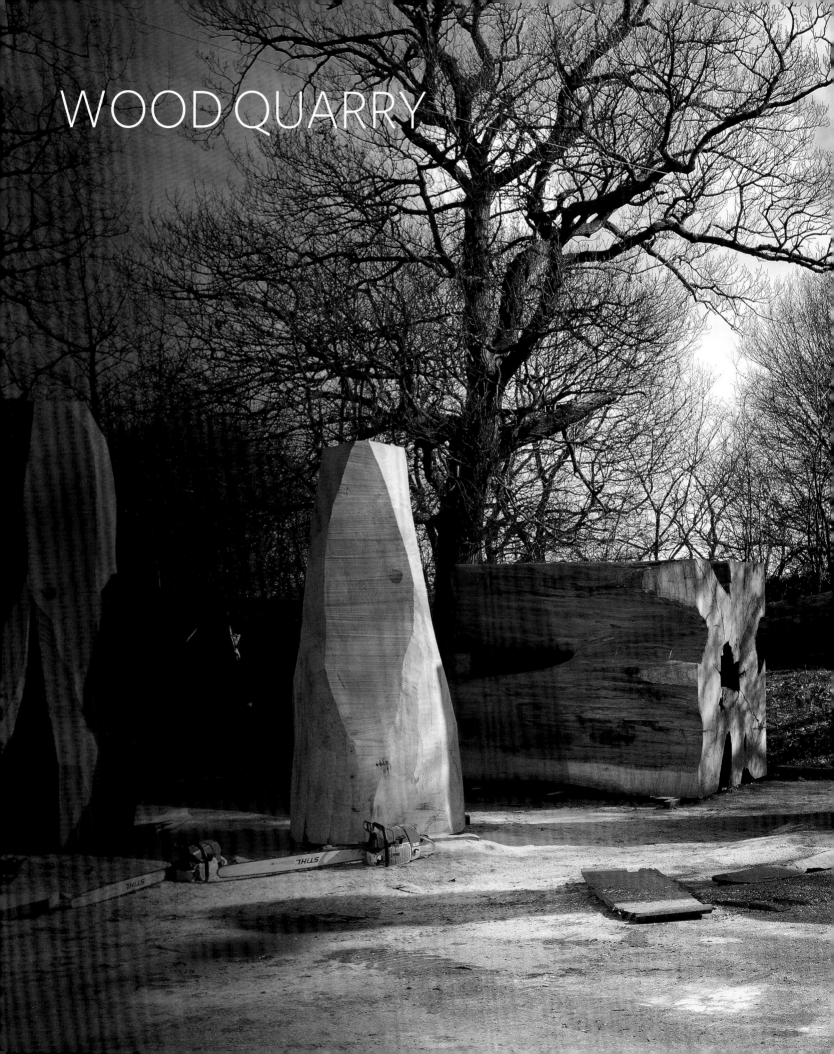

WOOD QUARRY

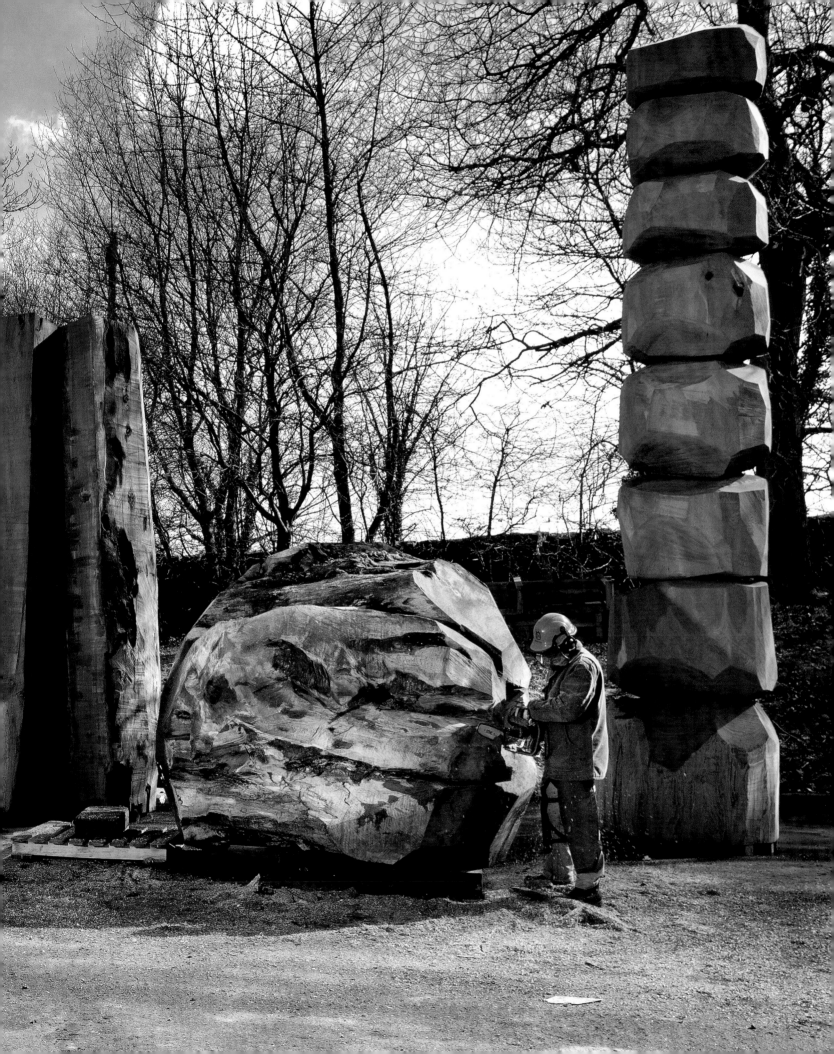

WOOD QUARRIES: OUTDOOR WORKSHOPS

A wood quarry is Nash's name for his practice of working with whole trees at the site where they came down naturally or were felled. Nash 'mines' the tree, 'excavating' forms from the mass of raw material. The work site becomes a wood quarry, a place of industry and discovery.

The first wood quarry was in Maentwrog, in the Ffestiniog Valley, and used an old oak that had lost a limb in high winds, making it unstable and a danger to the public. Nash began work in 1978 and for the next two years, whenever he had an idea, he would visit the site and carve from the tree. Working solo, he produced eight sculptures, including the *Wooden Boulder* and the first examples of *Cracking Box* and *Woodstove*.

This quarry was followed, in 1982, by the first overseas wood quarry, which took place in Tochigi, Japan. This project was an important development. It was here that the working method for future quarries took shape, with the essential elements being their collaborative nature and their intense three- to four-week timeframe. Nash found working in a collaborative team a revelation, encouraging new ideas and leading the

work into new directions. Many subsequent wood quarries came after, using the Japan experience as a blueprint. Among these were major projects such as *Chêne et Frêne* at Tournus Abbey in France (1988), which explored the contrasting nature of oak and ash; *Spirit of Three Seasons*, in Otoineppu, Hokkaido, Japan (1993–94), based on visits during spring, summer and winter, and *Més Enllà del Bosc* (1995) in Barcelona, Spain, where Nash was able to select 'terminal' tree specimens from the city's tree hospital. Over the years, Nash has received many invitations to work overseas, producing sculptures from a wood quarry at or near the trees' original locations. This has led him to work with a wide variety of woods, including, for example, mizunara and tamo in Japan; palm and olive in Barcelona, and eucalyptus and redwood in California. But as the majority of his work occurs in northern temperate regions, the woods he has the greatest familiarity and fluency with are temperate broadleaves such as oak, ash, lime, beech and birch. All these different woods have their own characters, with some also varying regionally.

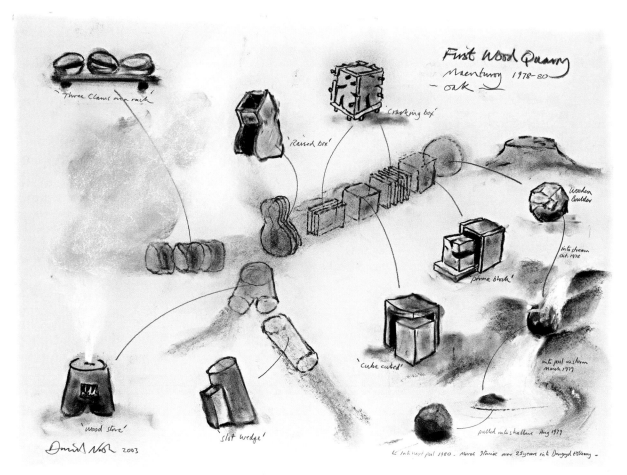

Previous page:
Nash working on *Big Butt* at Yorkshire Sculpture Park

Nash's first wood quarry was in Maentwrog, in the Ffestiniog Valley, from 1978–80. This drawing from 2003 illustrates how the sculptural shapes were formed from the oak trunk. Significant works resulting from this original quarry include *Wooden Boulder*, the first *Cracking Box*, and *Three Clams on a Rack*.

Sculptures taking shape at the Ashton Court wood quarry in Bristol, 1989.

'I realised I needed to try to be fluent with my material, to learn to "speak" wood, and allow the material to lead me.'

David Nash

THE CHARACTERISTICS OF WOOD

Sycamore

Sycamore wood is a benign, pale-toned wood with a consistent density that does not crack and warp as much as other deciduous woods, a property Nash works with when sculpting it. Sycamore's pale tone makes it very good for part-charred works, as its near white colour contrasts beautifully with black.

In the past, sycamore was commonly used for milking pails, as it does not sour milk, and is good for any food surface, such as chopping boards, bread boards and rolling pins. It is also the traditional wood used for violin backs and scrolls.

Beech

Beech has a pale, creamy tone, often with a pinkish-brown tinge, and when kiln-dried maintains this rich warm tone. If left outside to spalt and then dried, it takes on a marbled appearance. Beech carves willingly, and for Nash its substantial volume – trees can grow to 1.5 metres in diameter – makes it ideal for larger carvings. It makes wonderful *Crack and Warp* columns, splitting and bending dramatically as it dries.

In general use, beech's durability makes it good for furniture and it is the traditional wood for constructing workbenches. It also burns well, and makes the best fire logs.

Elm

According to Nash, the high water content of unseasoned elm makes it rubbery to work with, and, depending on where it was grown, it can smell vile. As it dries out, the surface becomes very dull and needs to be oiled to maintain presence and lustre. It has a consistent density so is good for carving and warps excellently, but does not crack. Due to Dutch elm disease, the wood is not now readily available.

Elm needs to be kept damp to maintain its durability and not rot. Before metal was widely available, the mains water pipes for several English towns were made of elm. It was also widely used for coffins.

Yew

Yew is one of the few woods with rich red heartwood, which contrasts with its light cream sapwood. Trees grow very slowly and many pre-date the ancient churches they often stand beside. For pagans, yew is sacred and has many spiritual associations, among these death, rebirth and the eternal. Nash finds echoes of such associations in both the growing tree and its wood, and always takes the opportunity to acquire yews that have reached the end of their natural life, although their longevity makes this rare.

Yew's characteristic strength, combined with flexibility, made it the preferred wood for medieval English longbows.

NASH'S WOOD QUARRY AT KEW

The wood quarry at Kew is the first that Nash has worked for a decade. It differs from earlier quarries by being run over a period of months rather than weeks, and is unique in being open to the public as an integral part of the exhibition. The site is the exhibition's productive centre, showing the work that transforms trees into sculptures.

The wood quarry process is flexible and dynamic, with Nash responding to the potential he sees in the material provided. In addition to his own wood, he will produce sculptures from Kew trees, made available through the Gardens' tree management programme. These trees are diseased or have reached the end of their natural lifespan.

Nash is starting the quarry by working with an English oak from Kew, which has been killed by a borer beetle infestation. The boughs and branches have been felled but the trunk has been left standing, still rooted in the ground, to be carved *in situ*. The other trees from the Gardens have been felled completely, and the wood will be transported to the quarry when required.

KEW TREES – SCULPTED BY NASH

Large-leaved lime
This tree, *Tilia platyphyllos*, originally stood near Kew's Lake and was well over 30 metres tall, with a canopy spread of more than 11 metres. Lime trees grow in the wild throughout Europe and it is Britain's tallest broad-leaved tree.

Freshly cut lime timber is soft, white or pale-yellow with a satin-like gleam. After exposure to air the colour changes to pale brown, and the consistency is firmer. Lime's balance of firmness to softness – its ratio of resist to give – makes it perfect for carving, especially for detailed work.

English oak and red oak
Both the English oak (*Quercus robur*) and red oak (*Quercus rubra*) originally stood on Kew's Cedar Vista. The former had a height of 21 metres and a spread of 8 metres, while the latter was slightly taller at 22 metres, with a canopy spread of 9 metres. English oak is common in British woodland and throughout western and central Europe. Red oak grows in the wild across North America.

Oak has a long life-cycle, growing and rotting slowly. An oak can live for well over 500 years especially if pollarded. English oak's durability lends itself to use in shipbuilding, and for ladder rungs, pillars and beams. Red oak differs in having little durability for outside use, but it is good for flooring and furniture.

White ash
This tree originally stood near Kew's Azalea Garden. In 1994 it measured 14 metres tall, with a canopy spread of 7 metres. *Fraxinus americana* is native to North America, hence its other common names of American ash and Canadian ash. It is a vigorous tree that grows rapidly.

Ash has grey-brown heartwood and is tough and springy. Its excellent shock absorbing qualities makes it ideal for tool handles and for sports equipment, such as cricket stumps and hockey sticks. It is one of America's most valuable timber trees and is also used for furniture and flooring.

Holly
This holly originally stood near Kew's Japanese Landscape. One of Britain's few native evergreens, *Ilex aquifolium* is common in woods and hedgerows across the country. Its spiky leaves act as a deterrent to grazing animals and protect the birds that feed on its berries.

Holly wood is tinged dull white or grey, and is dense and hard with an irregular knotty grain. It is a tricky wood to work with because it warps easily unless cut into small pieces and it is difficult to dry – but its beautiful finish makes the effort worthwhile. Holly has various uses, for example for making harpsichord hammers and billiard cue butts, but the majority of its uses are decorative.

'Once I am installed with all my equipment and the sawdust starts to fly, a dynamic chain of possibilities begins to reveal itself. The tree becomes a vein of material that I can excavate, the site becomes a quarry, vibrant with sawdust, big wooden shapes, off-cuts, branches and the working tools – saws, levers, chain hoist, winch: a wood quarry.'

David Nash

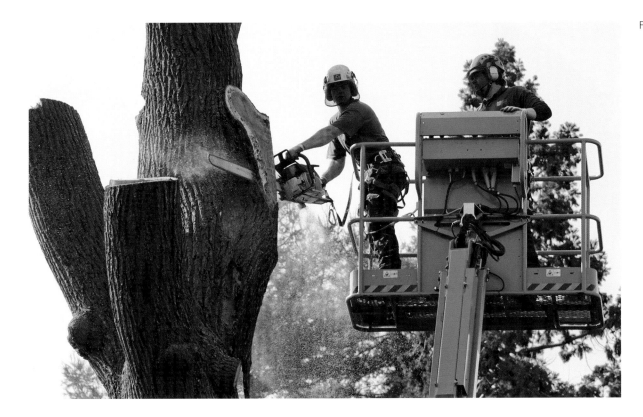

Felling the English oak.

Overleaf: At the wood quarry site Nash uses blackboards to chalk out plans, inform visitors about works in progress and explain some of his thoughts and ideas. This board illustrates his observation that 'The tree is a weave of earth and light'.

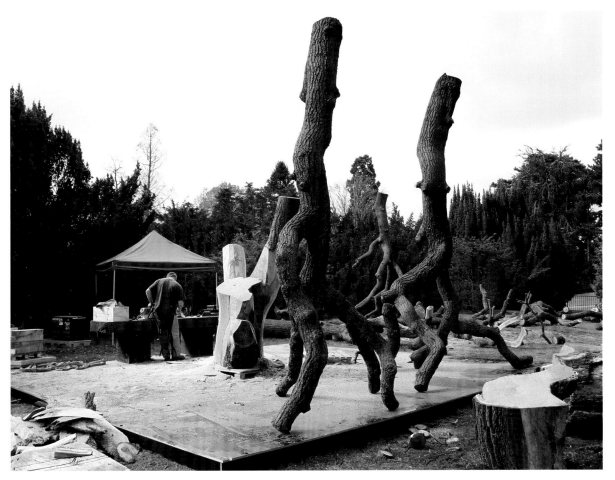

Work underway in the Wood Quarry.

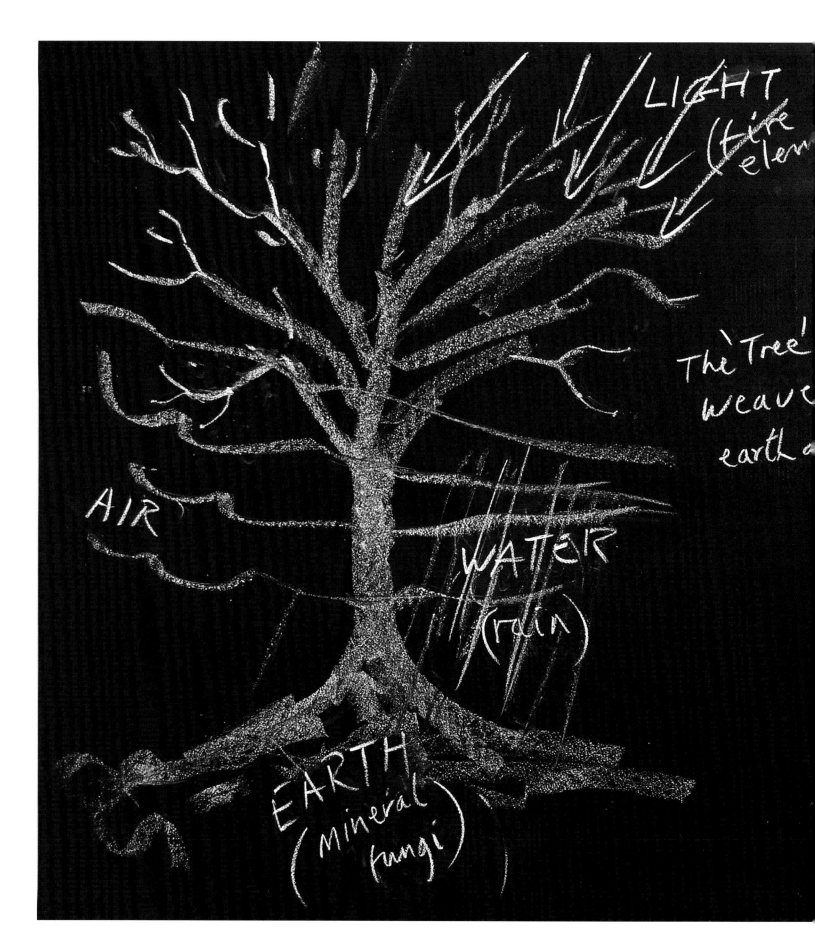

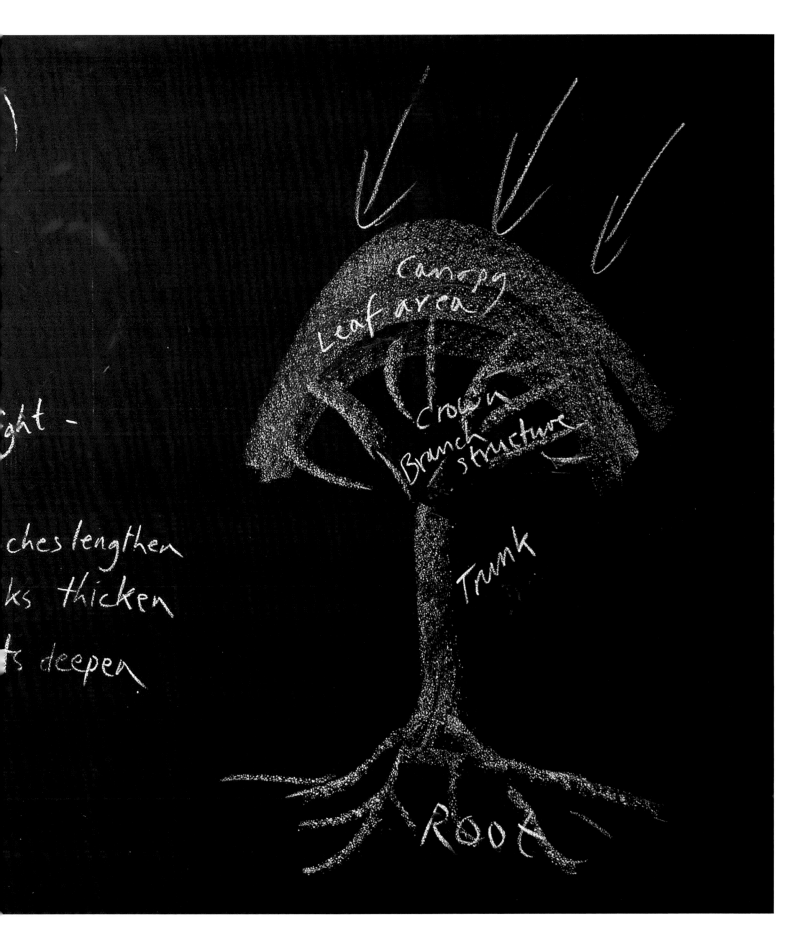

CHARRED WORKS

Nash began experimenting with fire during the 1970s but it was not until some years later he realised the potential for charring to become a regular process within his practice. The first large charred work was *Charred Column I* (1983), made in St Louis, USA. Nash observed how charring took away the immediate recognition of 'wood' and instead focused the eye on the form of the work. The way of seeing the sculpture changes – instead of the material having primacy, in charred works the form has primacy and recognition of the material is secondary.

Charring does far more than simply alter a sculpture's colour: fire doesn't colour the wood black, it transforms it from vegetable matter into carbon, a chemical element. This organic process mirrors how

Nash works with colour in his non-charred pieces, working with natural hues inherent in the wood and their organic changes over time.

Seven of the works displayed in the Gardens at Kew are charred. *Cairn Column* (2012), *Flame Column* (2012), *Black Sphere* (2004), *Charred Cross Egg* (2008), and *Black Dome* (2009) are charred oak. Oak shows resistance to charring and tends to flake off in thin layers; to make a permanent char skin particular processes are needed. *Black Trunk* is charred redwood and *Two Sliced Cedars* charred cedar. A further four partly-charred works can be seen inside the Temperate House: *Crag* (2007), *Cave* (2007) and *Red and Black Dome* (2006) are partly-charred yew, and *Comet Ball* (1995) is partly-charred elm.

Cube, Sphere, Pyramid
charring in Otoineppu,
Japan, 1993.

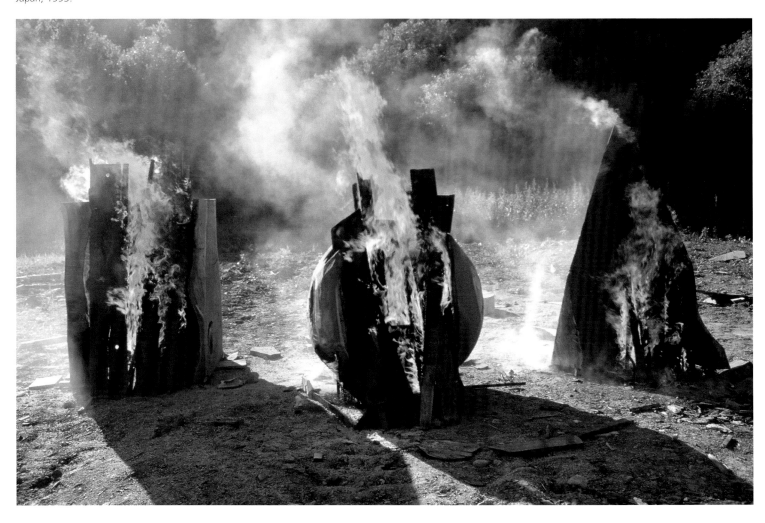

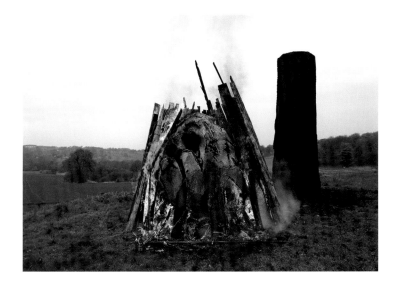

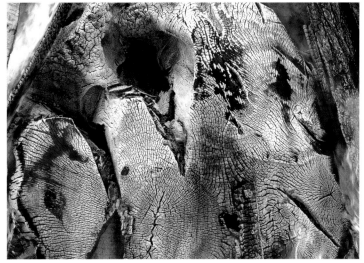

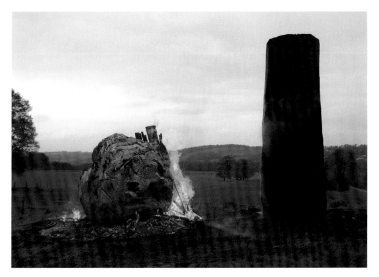

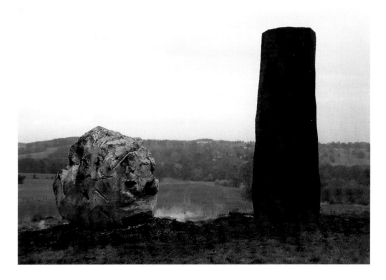

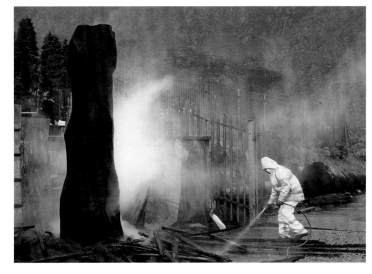

Charring *Big Butt* at
Yorkshire Sculpture Park.

Above: The charring
process in action at Nash's
studios in North Wales.

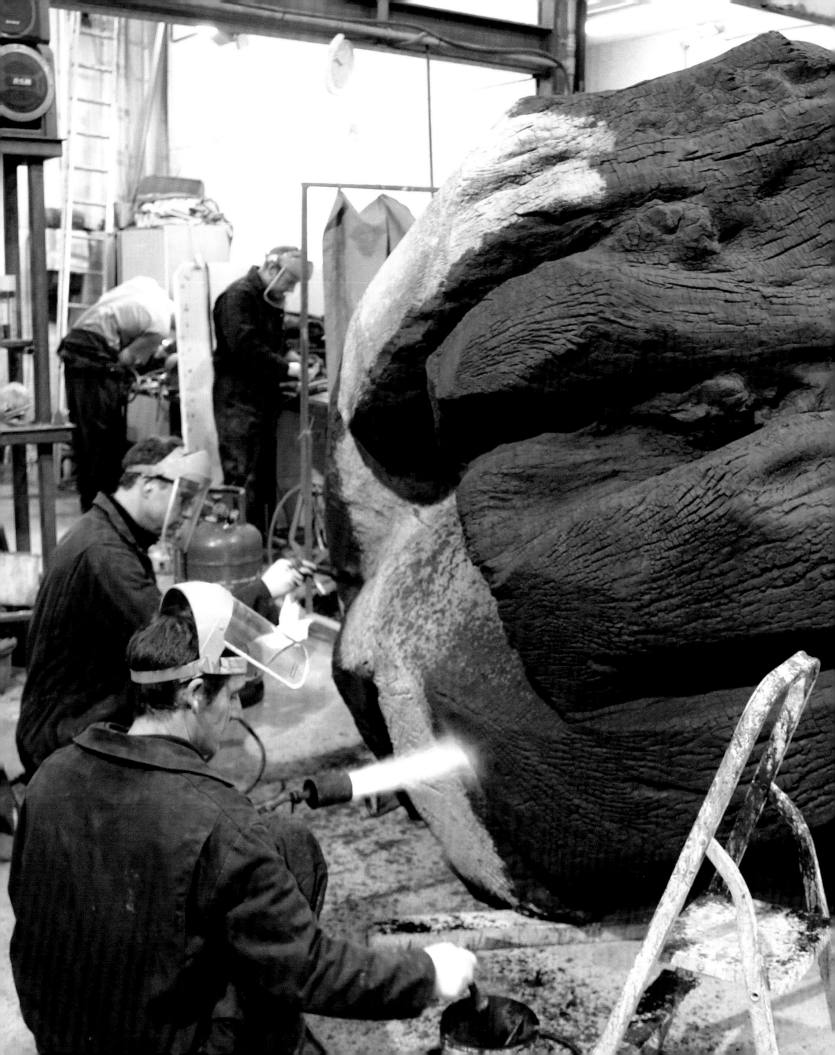

BRONZE WORKS

Over the last decade Nash has extended his practice by casting works in metal: predominantly bronze but also cast iron and Corten steel. His first significant cast work was made in 2000.

Bronze casting is a highly-skilled labour-intensive process; to cast *Black Butt* was six months' work for a full team of staff. It is especially involved when dealing with large-scale artworks like *Black Butt*, which was cast in 80 sections.

A process called lost-wax casting is used to cast artworks. This is a complex process but at a simplified level it involves making a series of positive and negative impressions of the artwork, starting with the first positive – the original artwork – and ending with the final positive, the bronze cast.

The first negative is a mould, which preserves the fine texture details of the original artwork. From this a wax cast is produced: this is a positive, an exact wax replica of the original. This is used to create the next negative, a hollow ceramic shell. It is into this shell that the molten bronze is poured. Once cooled, the outer shell is hammered and sand blasted off, revealing the bronze cast.

At this stage the work is welded together, if it has been cast in sections. The welds are disguised by 'chasing' the texture across the welds until they cannot be seen. Any imperfections are also reworked at this stage. Finally, the patina is added to colour the sculpture. The chemical used depends on the desired colour but in most cases the solution is painted on after the surface metal has been heated.

Five bronze works are exhibited in the Gardens as a group: *Black Butt* (2011), *King and Queen I* (2011), *Torso* (2011), *Three Humps* (2007), and *King and Queen II* (2008). Other metal cast works on display are the *Iron Dome* (2010) and *Three Iron Humps* (2009), and the Corten steel *Lightning Strike* (2008). Seven bronze works are displayed in the Temperate House: *Apple Jacob* (2009), *Cube, Sphere, Pyramid* (2010), *Crossed Egg* (2002), *Two Falling Spoons* (2006), *Seed* (2007), *Red Throne* (2012) and *Plateau* (2011).

Left: Applying the patina to *Black Butt* in the foundry.

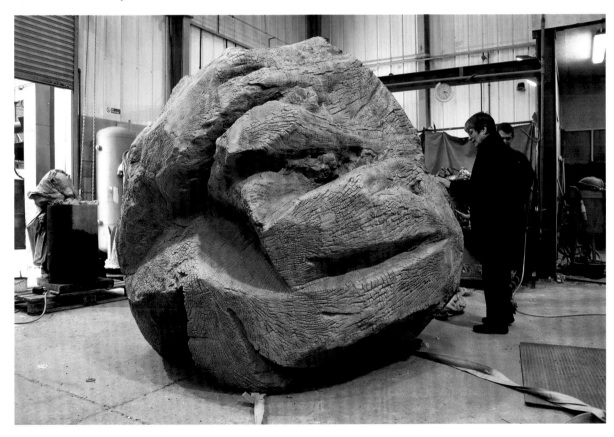

Black Butt in progress at the foundry.

OUTDOOR SCULPTURES

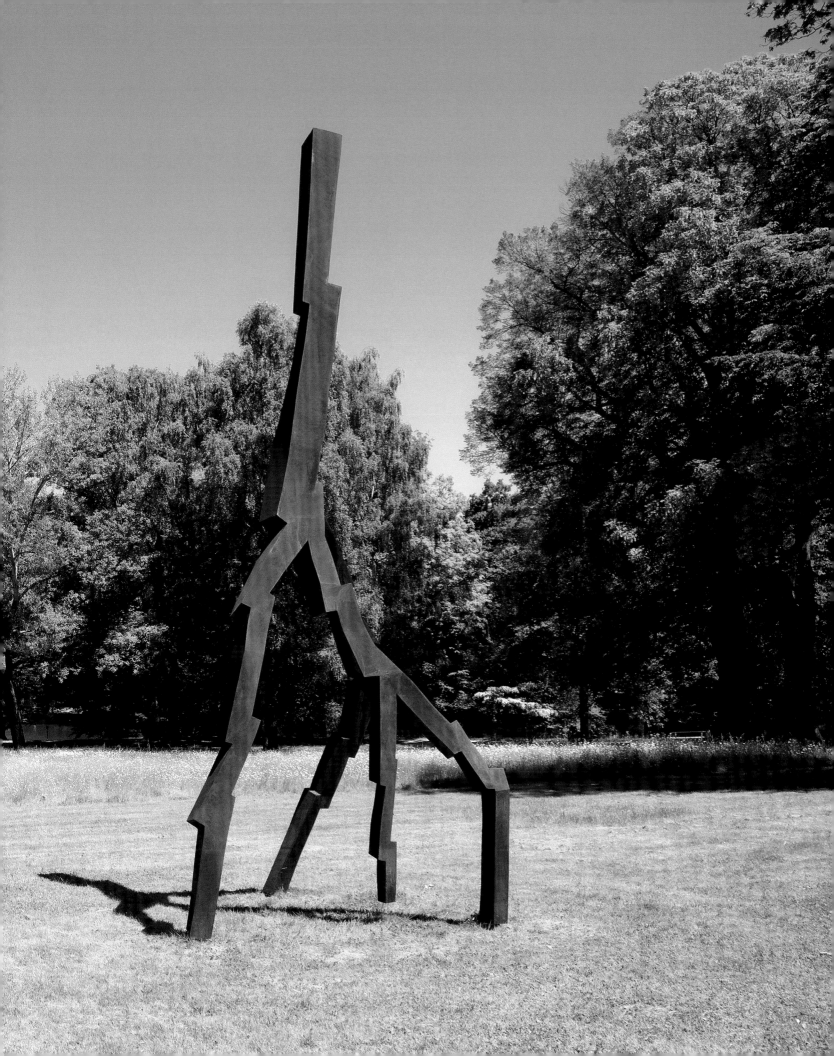

TWO SLICED CEDARS

Two Sliced Cedars is made from cedar wood, sourced in Sussex. Nash has chosen to char the sculpture to emphasise the form; the viewer's eye is drawn into the dense black, adding to the visual impression of a solid outline and dense weight. The difference in effect can be seen when you compare the stripped trunks (below) to the carved and charred sculpture (right).

For Nash's purposes, cedar is good because of its durability; cedar keeps better outdoors than many other species. Throughout history cedar has been used by humans mostly for the preservative and medicinal properties of its resins and oils: still today many of us are familiar with the practice of putting cedar wood balls in clothes drawers to deter moths.

For the duration of the Kew show, *Two Sliced Cedars* will be sited within view of a row of Atlas cedars (*Cedrus atlantica*), which line the avenue leading from the Shirley Sherwood Gallery of Botanical Art to the Temperate House.

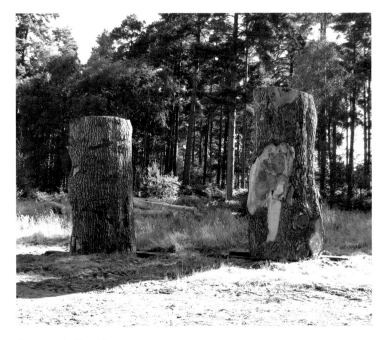

The unworked trunks of cedar.

Previous page:
Lightning Strike on display
in Bad Homburg, 2009.

Right: *Two Sliced Cedars*
(2010), charred cedar.

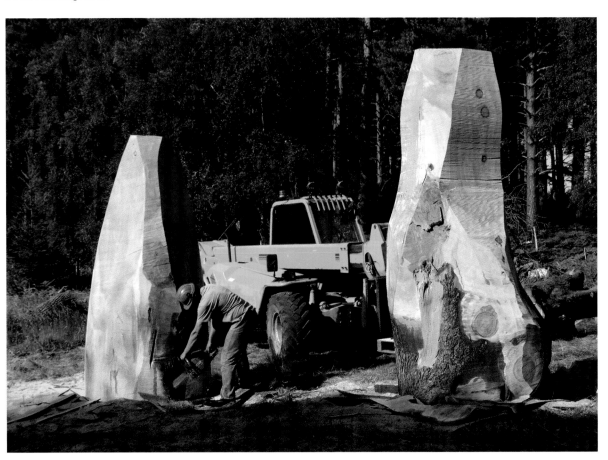

Removing the bark and sapwood.

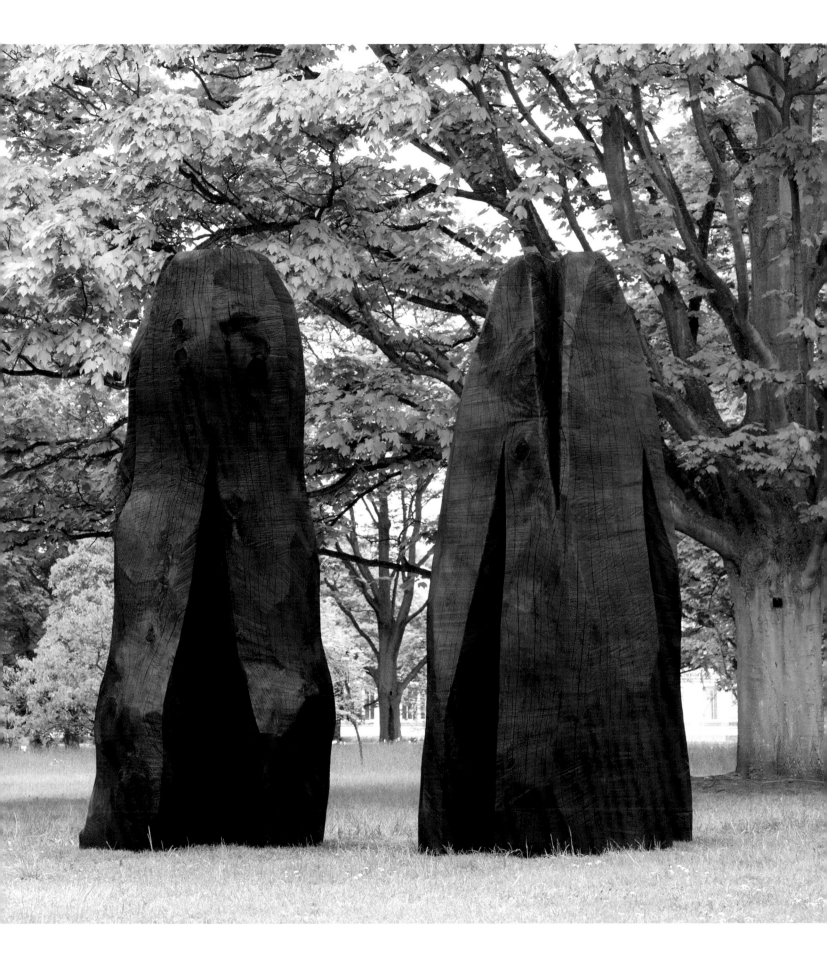

CORK DOME

The cork for *Cork Dome* was sourced by Nash during a trip to Portugal in 2010, staying in a cottage on a cork farm during the harvest period, where he gained insight into the entire process.

Cork oak (*Quercus suber*) forests are protected by the European Union. In Portugal, which has the world's largest area of cork oak forest, the trees cannot legally be cut down except as part of a forest management programme. Trees are only harvested once they reach maturity, when the trunk measures over 70 centimetres in circumference. Then they can be harvested every 9–10 years. Each forest has a harvest cycle, with some trees harvested while others are left to grow. After being stripped, each tree is marked with the year of its harvest. The first two harvests produce cork suitable for use in many products including flooring and insulation. The third and subsequent harvests can also be used to manufacture wine stoppers.

Harvesting cork is skilled work. The outer bark is prised off the tree's trunk and major branches using a careful technique that ensures the living layer of tissue beneath is not damaged. This stripping is done by hand, using specialised axes. Harvesting can only take place at specific points in time, when the bark comes away from the trunk easily. Once collection is complete the bark is piled into big stacks and left to season for at least six months, until its moisture levels have stabilised.

The *Cork Dome* will be constructed at Kew and sited outside the Shirley Sherwood Gallery of Botanical Art, where drawings and a film of the cork harvest can be seen.

Cork farmers use specialised axes to hand-strip cork from the trees trunks and major branches.

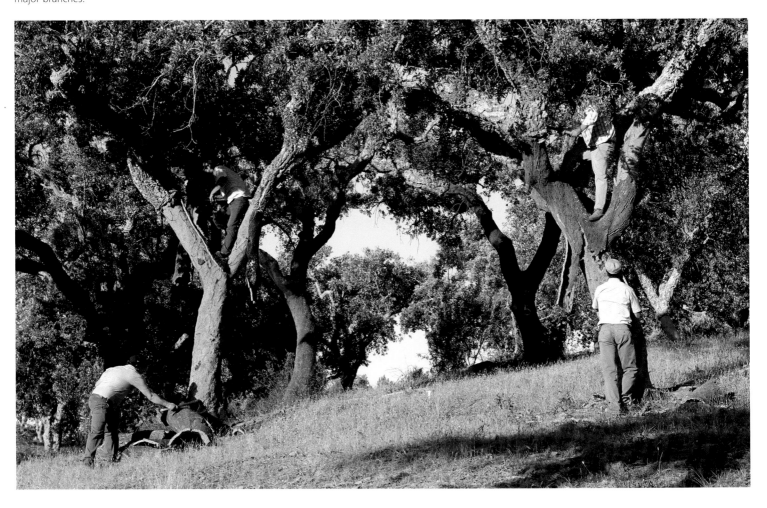

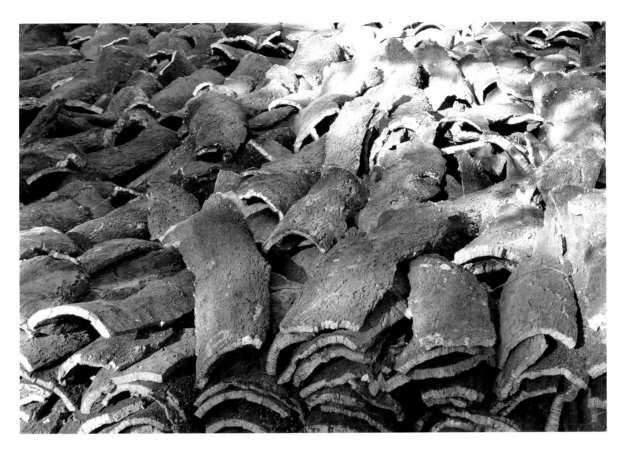

After harvesting, the cork is stacked and left to season.

A pastel drawing, charting the changing colour of the stripped tree trunks. When freshly-stripped the bark is pale amber, turning to red after 24 hours. From there it turns a deep red, then black, finally fading to grey. To ensure accuracy Nash colour-matched these against tree trunks in the cork forest.

The artist's pastel drawings showing cork trees at different stages of regrowth.

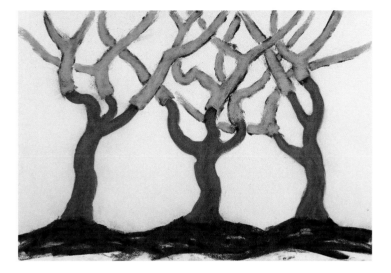

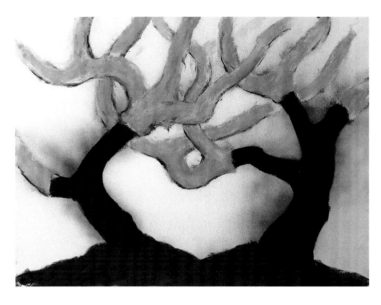

Cork Dome (2012), cork oak.

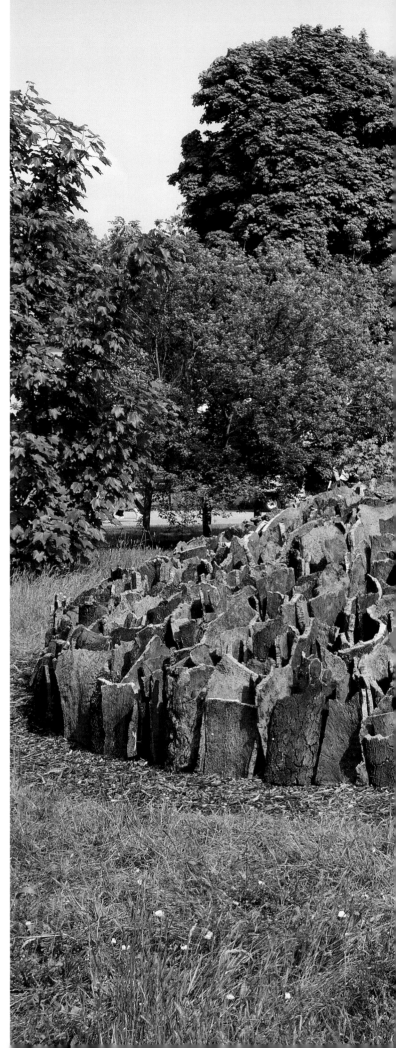

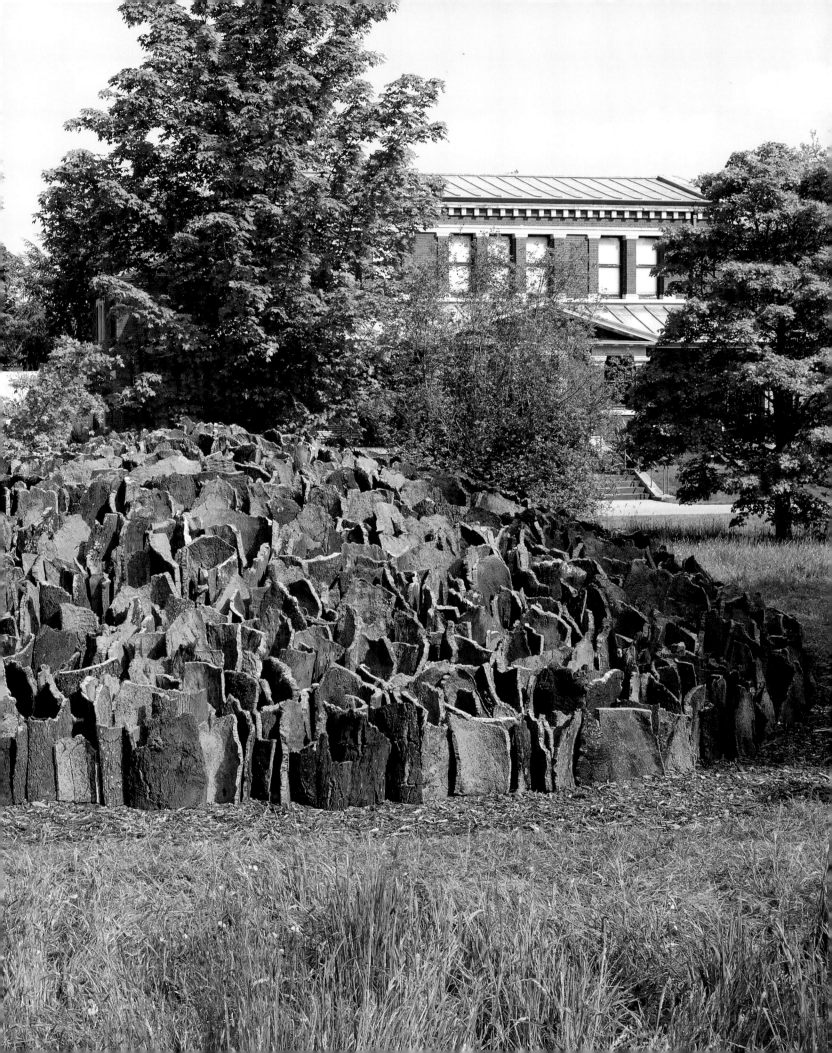

CHARRED CROSS EGG

Charred Cross Egg demonstrates how, for Nash, there is not always a given point at which a work is fixed and final; instead works can evolve, developing further over time. Exhibited works can subsequently be taken further or led in a new direction. In its earliest incarnation *Charred Cross Egg* was 'Big Bud', developed for an exhibition in Lewes, Sussex, in 2007. While on outside display it was vandalised but Nash, with characteristic pragmatism, saw this as an opportunity to re-explore the sculpture and create something different. He carved out crosses that look almost stamped into the sculpture's surface and added a deep char to accentuate the cut-away form. The result was *Charred Cross Egg*, a work that, given its genesis, appropriately combines two symbols associated with new life.

Cardboard templates were used to work out where best to carve the cross shapes.

The crosses were carved using a small chainsaw.

Right: *Charred Cross Egg* (2008), charred oak.

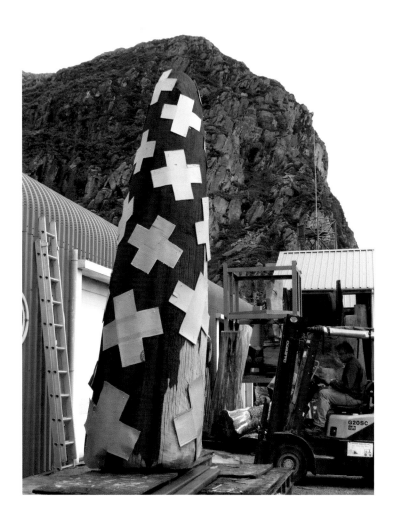

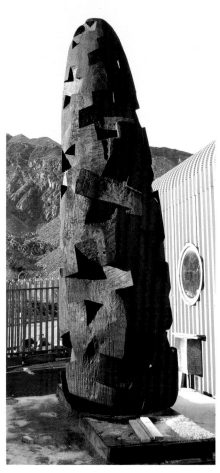

Standing complete and charred, outside Nash's Blaenau workshop.

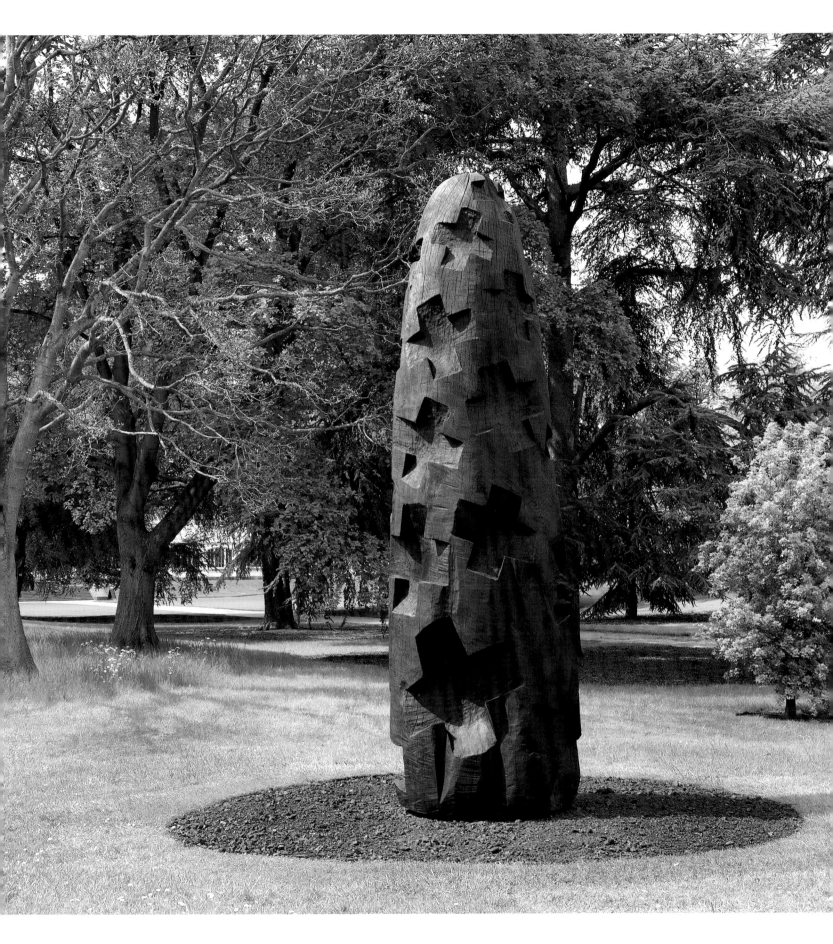

LIGHTNING STRIKE

The name *Lightning Strike* derives from its zig-zag form: a likeness even more visible and vivid in this raw metal incarnation. The name's reference to the elements has further resonance given that *Lightning Strike*'s surface will be visibly altered by exposure to the weather.

The original *Lightning Strike* was made with an ash tree, which fell in the Great Storm that swept southern England in October 1987. Nash anticipated the original sculpture, which stood in the grounds of a collector's estate, would last for ten to 15 years and this transpired to be so. But before the original completely disintegrated templates were made enabling the Corten steel versions to be produced.

At Kew, *Lightning Strike* will be positioned close to the Temperate House, linking these internal and external exhibition spaces. Leggy, animated forms recur in Nash's work. A further example with a strong visual affinity to *Lightning Strike* can be seen inside the Temperate House. That work – *Apple Jacob* – has also experienced new life, as a bronze cast was made from the apple wood original.

The original ash wood *Lightning Strike*. This wood version had some edges softer than the metal-cast versions.

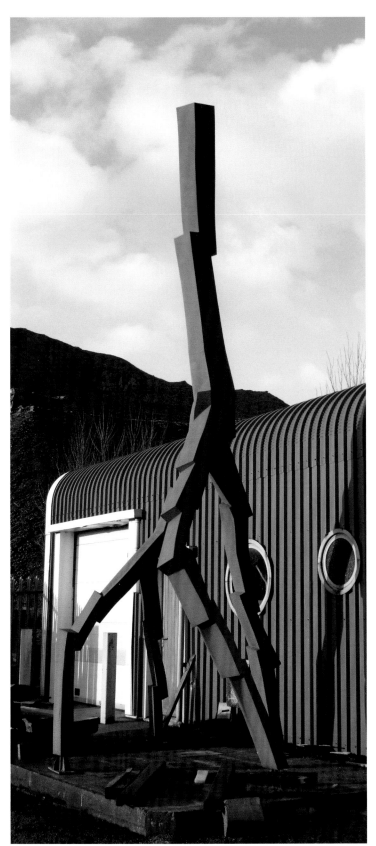

Lightning Strike outside Nash's Blaenau Ffestiniog workshop.

Right: *Lightning Strike* (2008), Corten steel. On display in Bad Homburg, 2009.

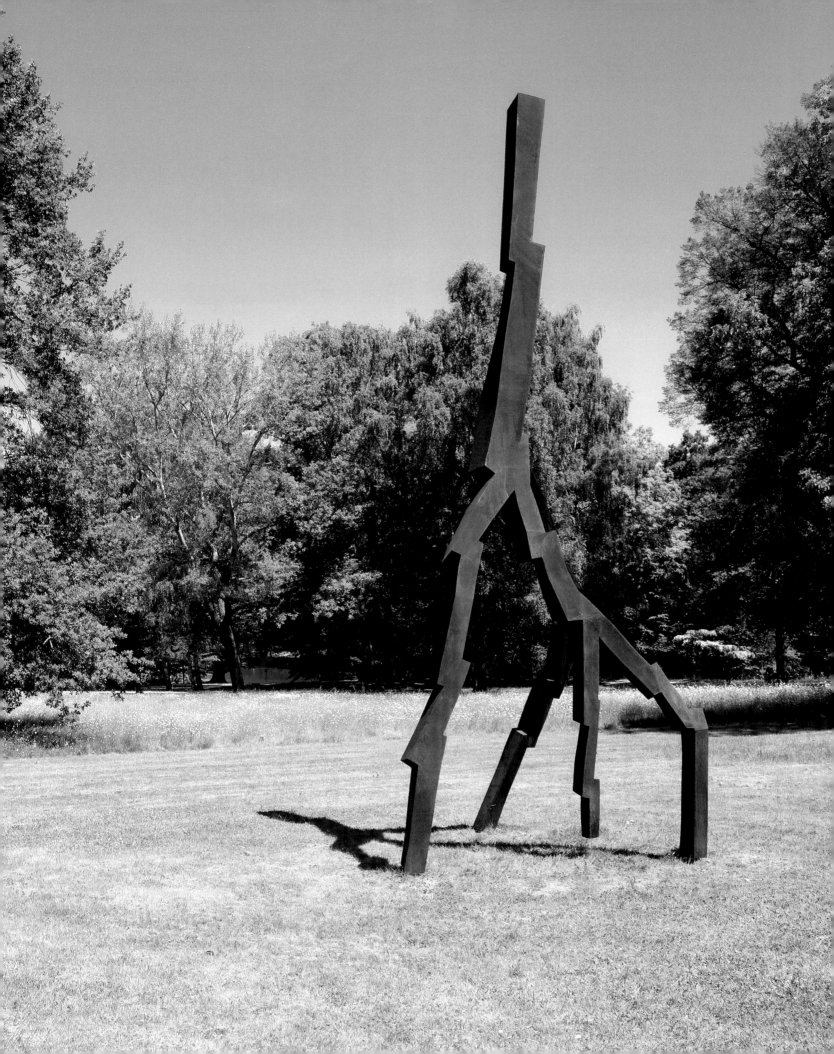

BLACK DOME

The original *Black Dome* was a commission for the Forest of Dean sculpture trail, and was formed of 900 charred larch logs arranged into a dome. The work was intended to 'return', to re-join the earth and the natural cycle of life and death by fungal decay over a period of years, leaving behind just a trace of its original form. What was not envisaged was the public's desire to engage in the work by walking over it, altering the sculpture's appearance and hastening its return.

The *Black Dome* on display at Kew was created in 2009 for Blackwell House and has subsequently been shown at Yorkshire Sculpture Park. It is made from more than 70 lengths of oak, carved and then charred before being assembled in rings to form the dome.

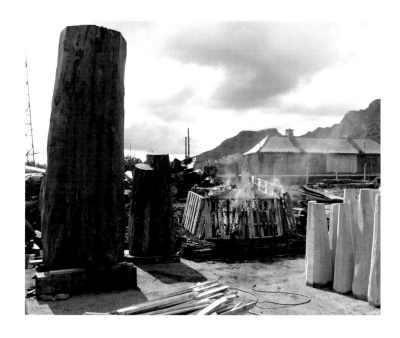

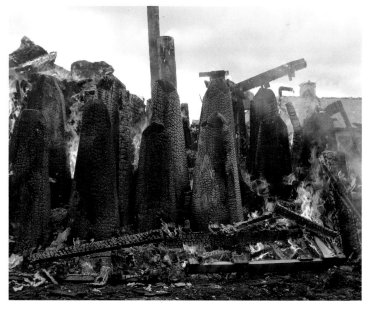

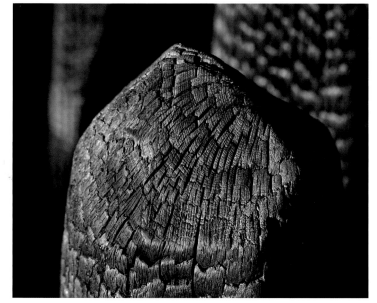

Charring the *Black Dome*: sections burn, while others wait their turn.

'All that we do, what we make, feel, think, is pitched into the relentless stream of time. In this stream the elemental forces of nature give their energy to what is coming, growing, evolving and destroys what is failing, going; reabsorbs, recycles, reintegrates.'

David Nash

Right: *Black Dome* (2009), charred oak, at Blackwell House.

BLACK TRUNK

Black Trunk is made from redwood sourced from California, where the work was also carved. For use in sculptures, redwood offers good colour and great solid mass. They have very thick bark, which protects the trees from forest wildfires.

To create *Black Trunk*, Nash followed the natural form of the wood, cutting out the rot and working with the naturally-formed fissure in the trunk. The work was later charred by being enclosed in a kind of wooden teepee formed by carefully arranged planks of wood, which were then set ablaze. After burning for a set period of time the fire was put out and the surface cooled.

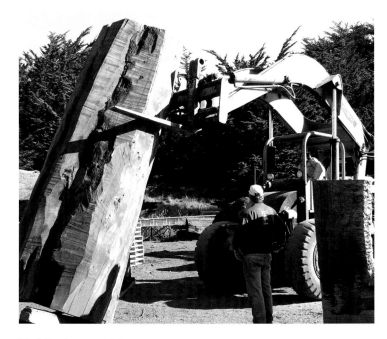

Black Trunk as a work in progress in California.

Right: *Black Trunk* (2010), charred redwood.

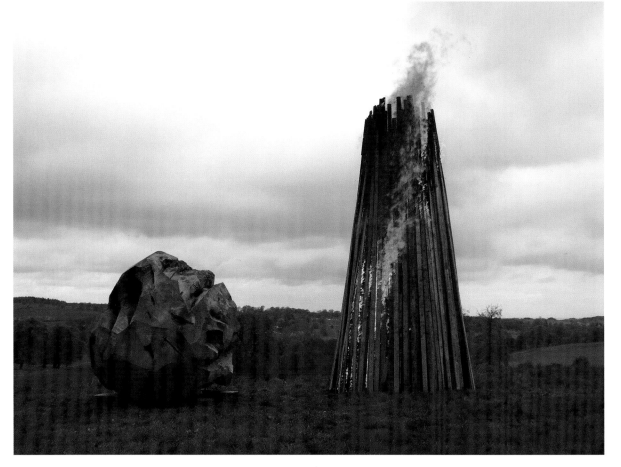

The charring of *Black Trunk* at Yorkshire Sculpture Park, with *Black Butt* to its right.

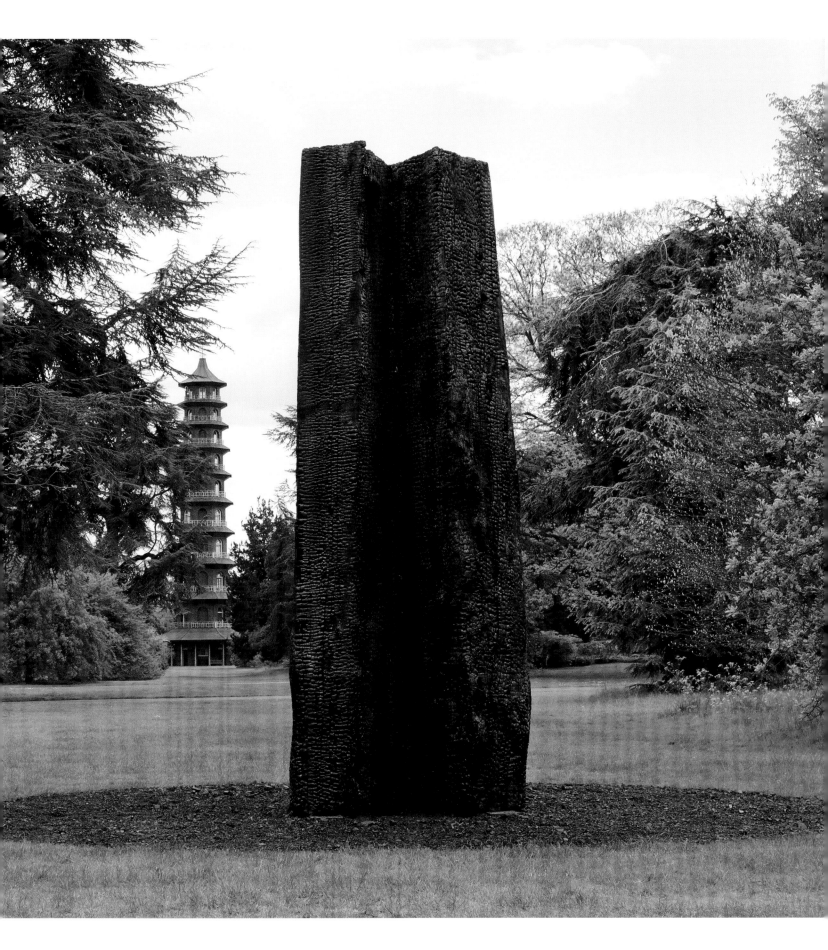

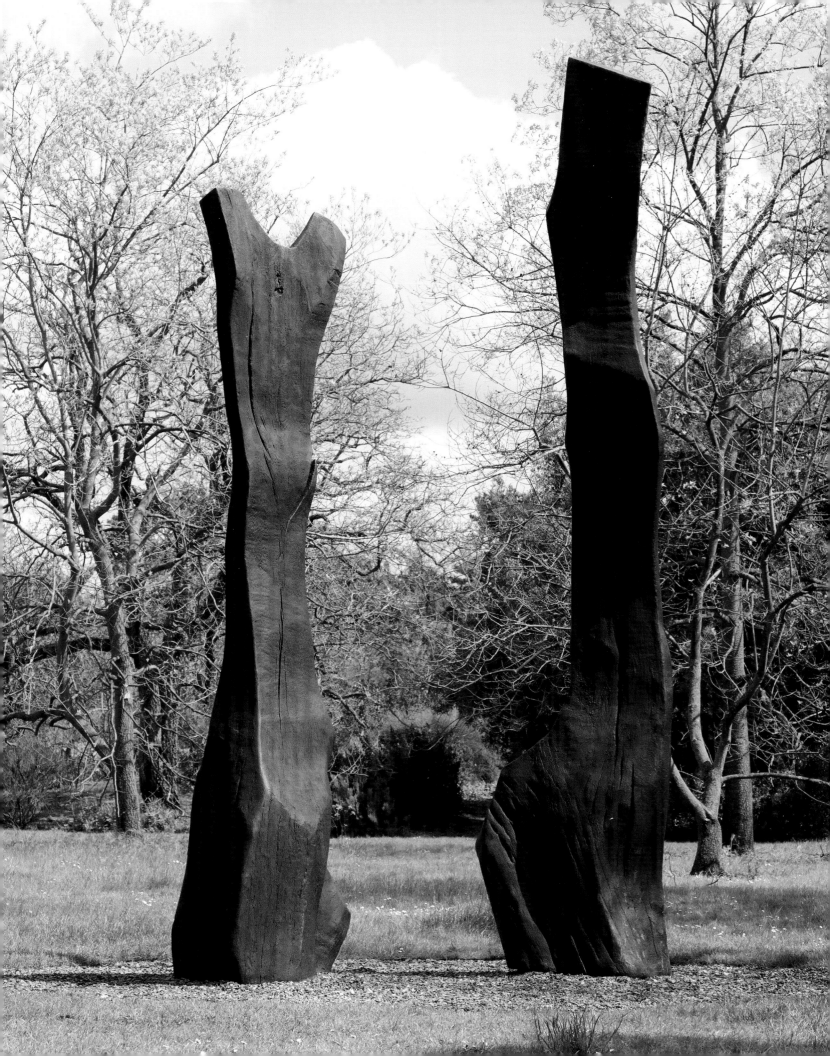

KING AND QUEEN I AND II, BLACK BUTT, THREE HUMPS AND TORSO

These bronzes were cast at fine art foundries in Wales and Germany, from original wood sculptures that would not last well outside due to the intricacies of their form. The original *Black Butt* was made from elm, the others from oak. Whereas *Black Butt* and *Three Humps* are abstract, *Torso* and the two pairs of regal Kings and Queens stand out as highly-animated, figurative works.

Nash has found that charred works best lend themselves to bronze casting. The finished patinated surface of the bronze takes on the colour and original texture detail of the wood so convincingly that the eye simply cannot discern the difference.

Left: *King and Queen II* (2008), bronze.

King and Queen II (2011), charcoal on paper.

Black Butt (2011), bronze.

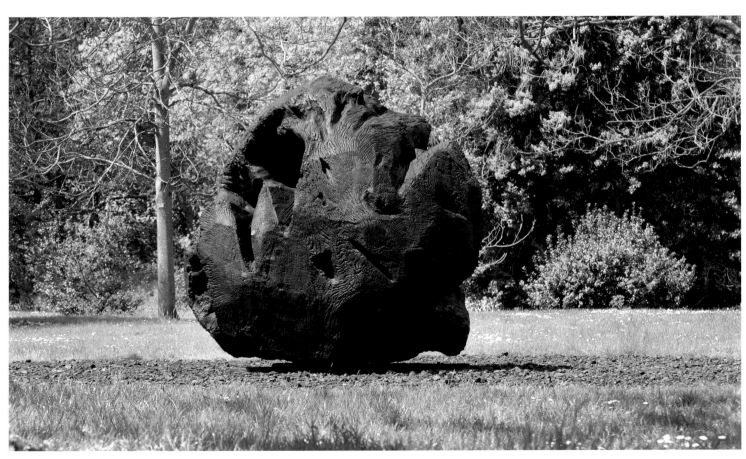

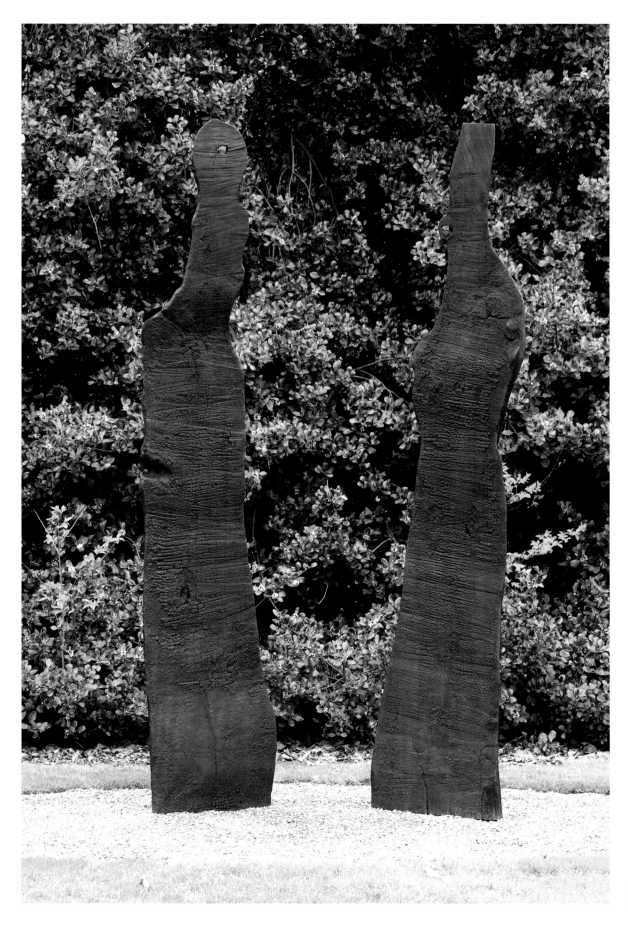

King and Queen I (2011),
bronze.

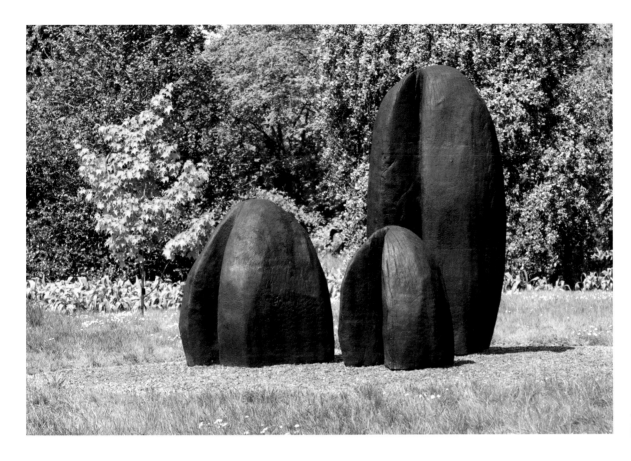

Three Humps (2007), bronze.

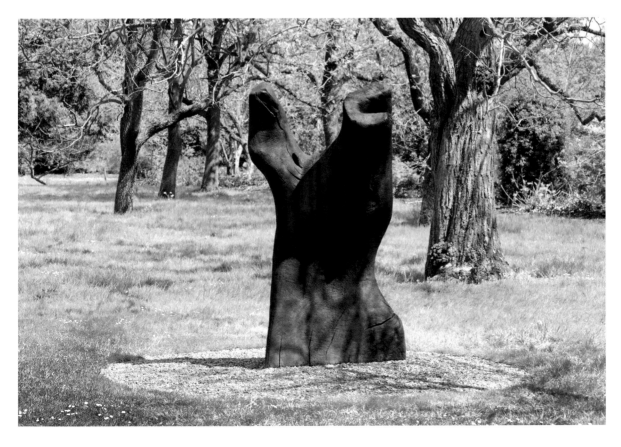

Torso (2011), bronze.

THREE BUTTS

Three Butts is made from eucalyptus sourced from California, where it is being cleared. Eucalyptus was introduced to California in the 1850s to use as fuel for locomotives but has spread to become a significant threat to native flora and fauna.

Nash cut these sections for a three-part carved sculpture but so liked so much the raw, unworked natural shapes that he decided to keep them in that form. Together they have great presence and speak of the density of eucalyptus – the biggest of these butts weighs approximately 11.5 tonnes, whereas a similar-sized piece of oak would be half that weight. Since arriving in Europe in 2009 they have been exhibited constantly and signs of aging are evident, so after the exhibition at Kew they will be carved as originally intended.

This bold use of large, simple forms is apparent in many of Nash's recent sculptures, for example in his other eucalyptus work *Oculus Block*. These works reveal the artist's mature confidence, as well as underlining the truth of the maxim that 'less is more'.

Red wedges hold the wood apart at the original cut point, so it doesn't pinch the saw as it cuts through the trunk.

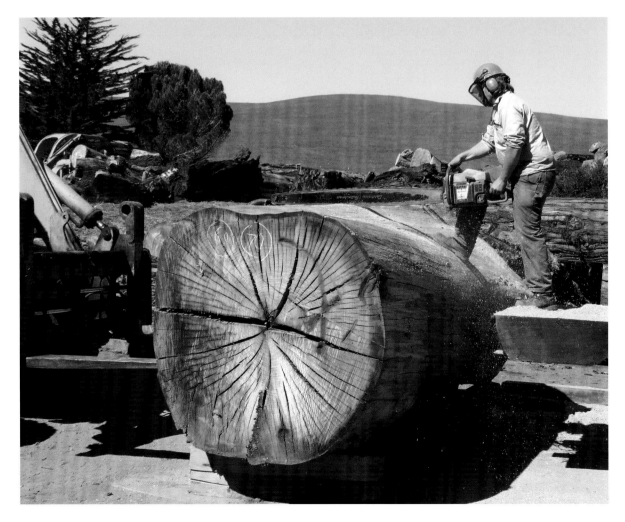

Sawing the lengths of *Three Butts*. The original colours of the wood can be seen here; as the work has been exhibited these colours have changed, dulling through exposure to the elements.

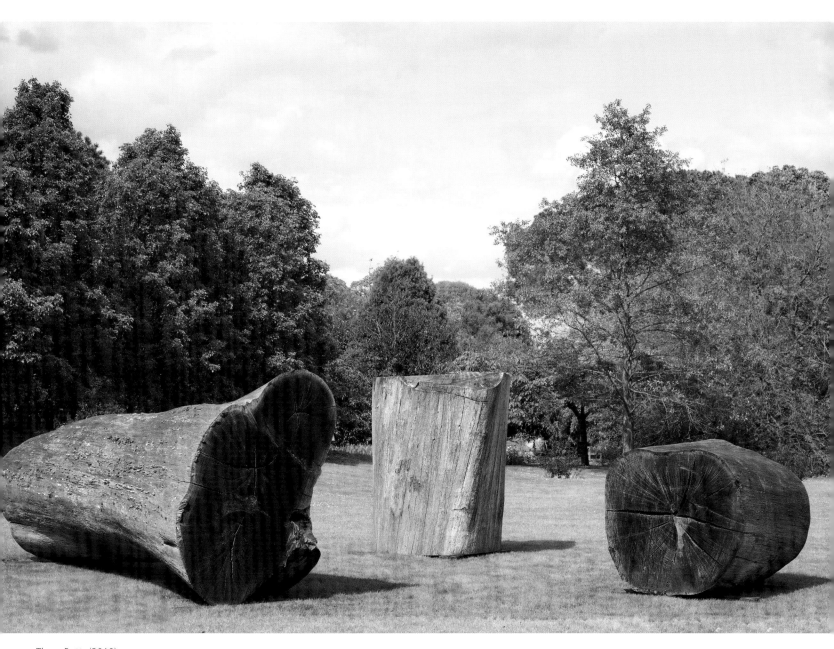

Three Butts (2010),
eucalyptus.

*'I realised I needed to try to be fluent with my material, to learn to
"speak" wood, and allow the material to lead me.'*

David Nash

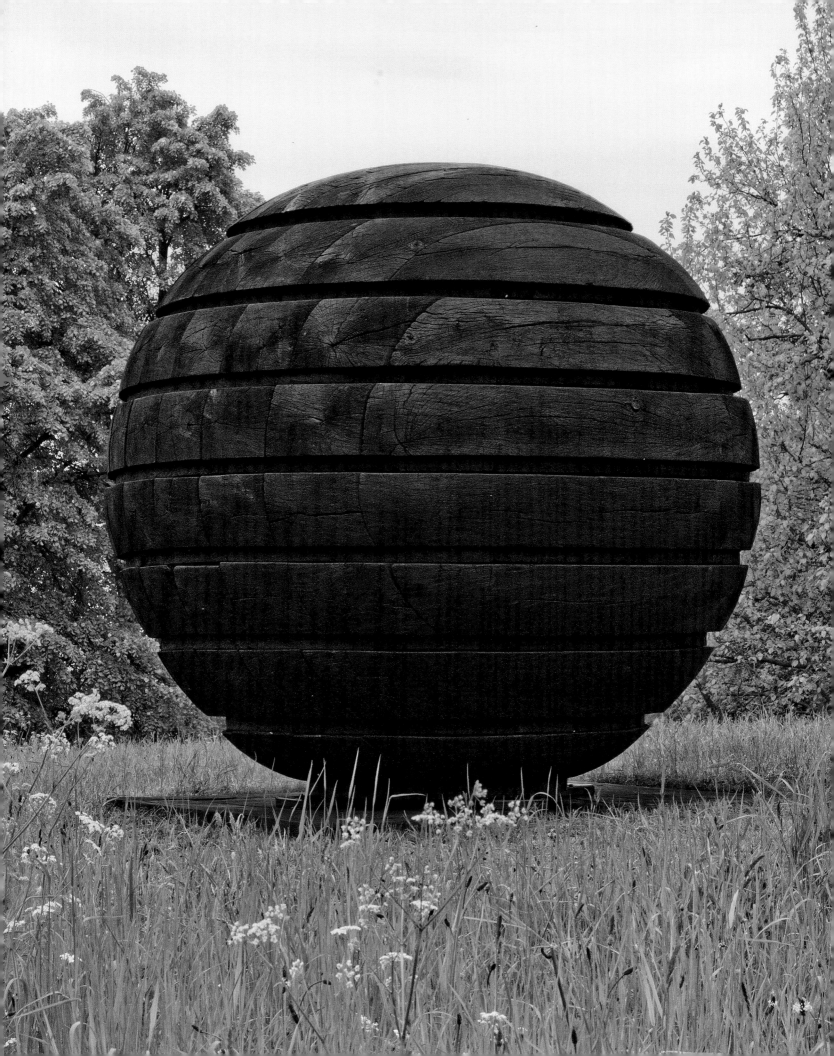

BLACK SPHERE

Black Sphere contains echoes of Nash's *Cube Sphere Pyramid* works and his celebrated *Wooden Boulder*. It is constructed from oak beams of varying diameters layered and slotted together to form the sphere. The use of layers introduces horizontal lines, accentuating the form's circular nature. Nash has explored this further in some of his universal forms sequences such as *Pyramids Rise, Spheres Turn and Cubes Stay Still*. In these works the universal forms are enhanced by straight lines: vertical on the cube, horizontal on the sphere, and diagonal to the pyramid.

*'The sense of the Cube
is solid unmoving
representing Matter*

*The sense of the Sphere
is one of movement turning
representing Time*

*The sense of the Pyramid
is rising expanding
representing Space.'*

David Nash

Left: *Black Sphere* (2004),
charred oak.

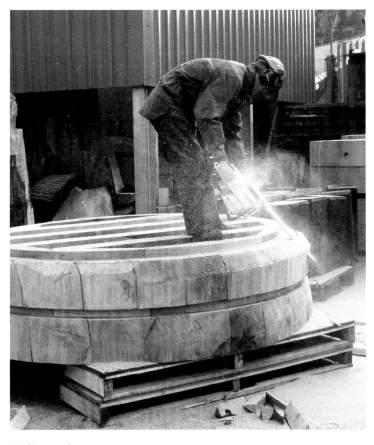

Working on the
Black Sphere.

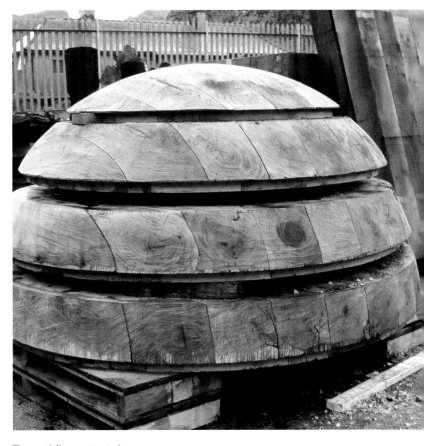

The partially-constructed
and uncharred *Black Sphere*.

OCULUS BLOCK

Oculus Block was created from a mighty eucalyptus tree, grown in California where the trees are being cleared, as they are a significant pest to local flora and fauna. This gigantic tree was formed by four individual trunks fusing to become a single tree with a space – the 'oculus' (meaning eye in Latin) – running right up its length. Nash was originally sourcing eucalyptus with the idea of making a giant sphere but the intriguing squarish shape of the tree immediately suggested a block form.

It was a full day's work to mark up and make a single cut. The trunk's girth was so vast a specially-constructed two-man saw measuring 3.6 metres in length was needed for the job. Once carving was completed, the finished sculpture weighed in at a hefty 10,000 kg. The scale of *Oculus Block* dwarfs its human onlookers. This, together with the sculpture's impressively simple form, speaks eloquently of the raw power and presence of wood.

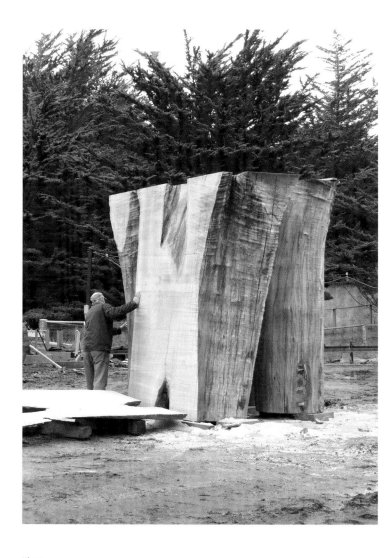

Oculus Block as a work in progress in California.

The trunk with chalk marks to indicate cut points.

The two-man saw alongside more averagely-sized chainsaws.

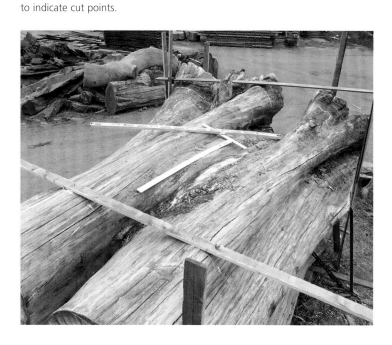

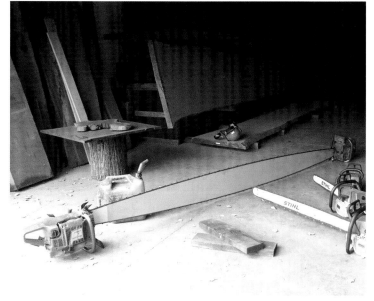

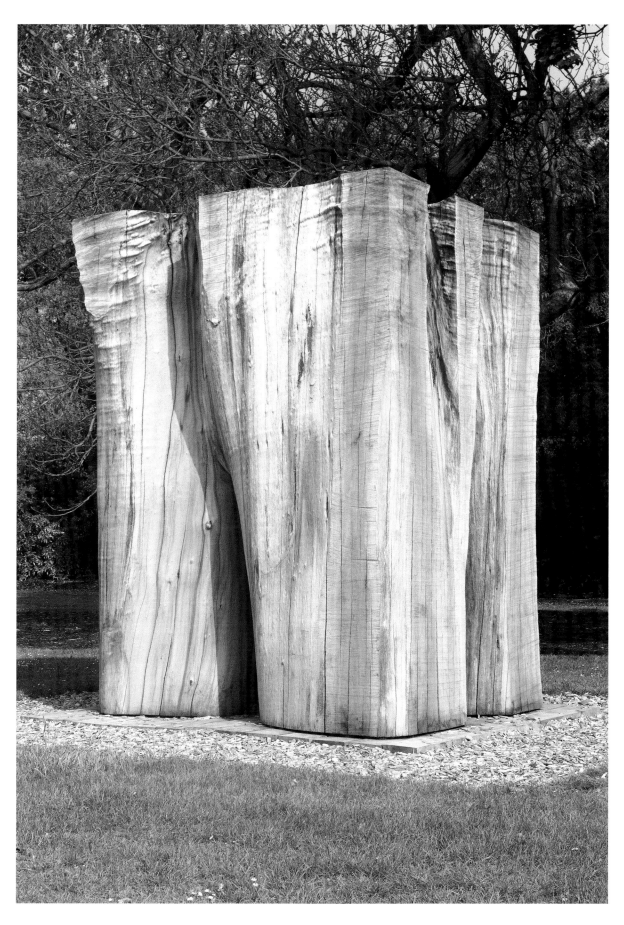

Oculus Block (2010),
eucalyptus.

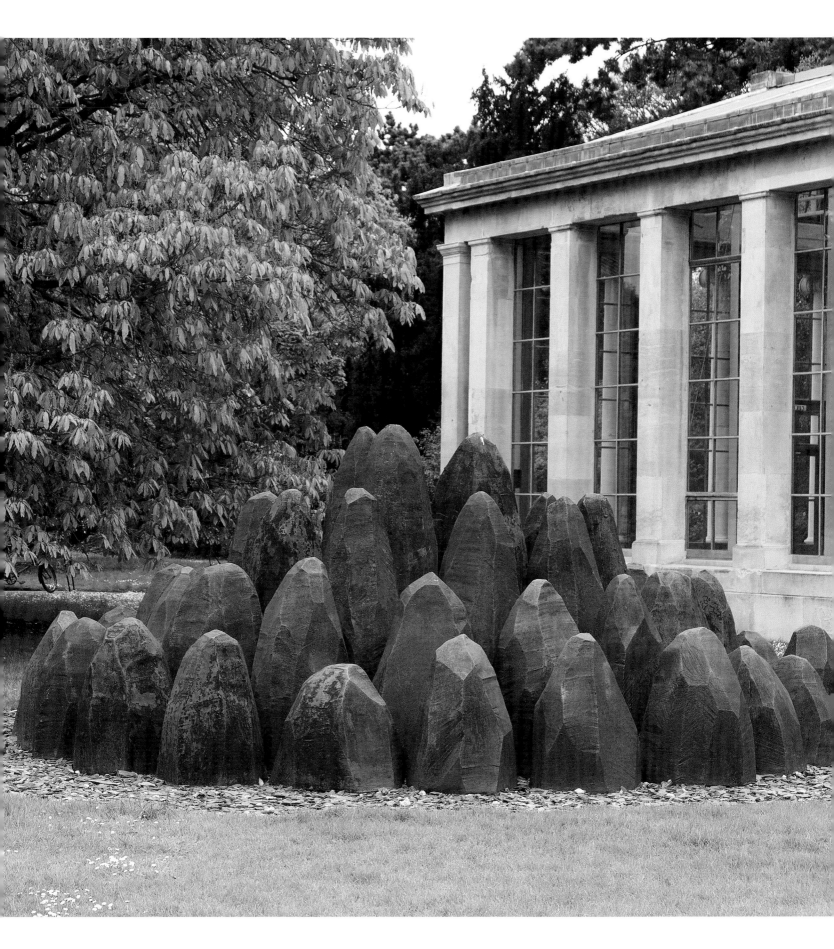

IRON DOME

Iron Dome consists of many cast iron pieces of varying heights. The sculpture was made in China by producing polythene blocks cut with hot wire, which were then cast in iron. Two identical copies were cast, one of which is kept on permanent display at Shanghai Sculpture Park.

The shape of both the individual pieces and the whole reflect China's scenery and topography as represented in Chinese landscape paintings. Nash has always been drawn to this simple, elegant style of painting and the typically strong vertical lines used to represent the mountains. On a trip to China to work on the sculpture he was gratified to see these shapes evident everywhere in the landscape.

As installed at Kew the work also carries an echo of Nash's home, at the foot of a Blaenau Ffestiniog slate tip, as the irons have been bedded in grey Blaenau slate. The slate contrasts in colour and texture to the irons, whose surface will continue to change with exposure to the elements.

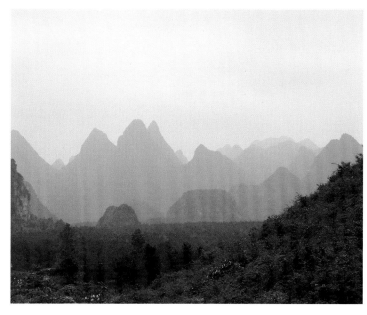

The incredible mountainous landscape of Guilin, north Guangxi, China.

Iron Dome (2010), cast iron.

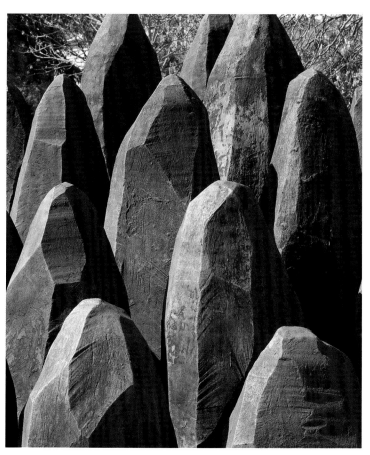

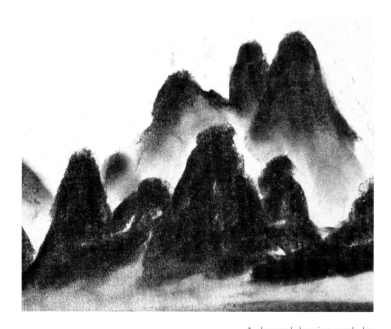

A charcoal drawing made by Nash while visiting China.

CAIRN COLUMN, FLAME COLUMN

Cairn Column and *Flame Column* are two new works for the exhibition at Kew, both made with oak from trees grown in Sussex.

The oak used for *Flame Column* was wide and straight but when the bark was removed Nash discovered it had many more rot spots than anticipated. Once these had been carved out the contours suggested the final shape. In the charring process the fire burnt through the centre of the fissures. Taking a lead from this new development, Nash further accentuated these spaces to create flashes of light as the viewer walks around the column.

Cairn Column is made from a high-quality piece of Sussex oak, free of any decayed areas, unusually for a tree of this age (more than 200 years). The trunk had a natural lean, which Nash worked with to create the animated, slightly askew form. The column was charred in fire to erode the sharp facets, scraped down, and then given a second charring with a propane torch, resulting in a deep, tight, even char.

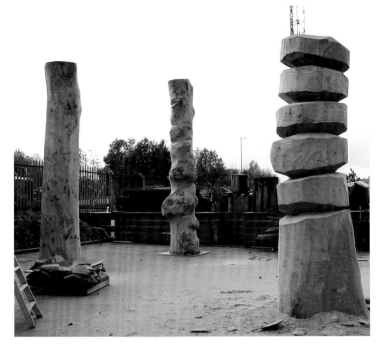

Cairn Column in progress outside Nash's Blaenau workshop, October 2011.

Right: *Cairn Column* (2012), charred oak.

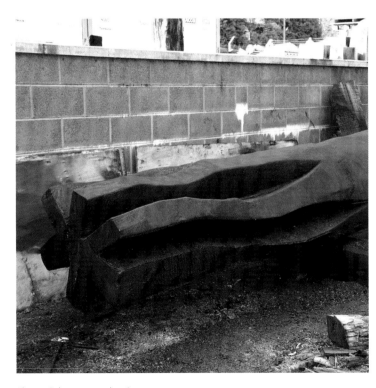

Flame Column post-charring, January 2012.

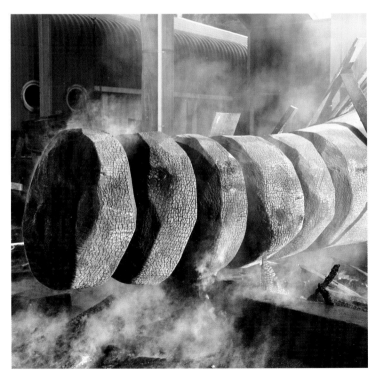

Charring *Cairn Column*, January 2012.

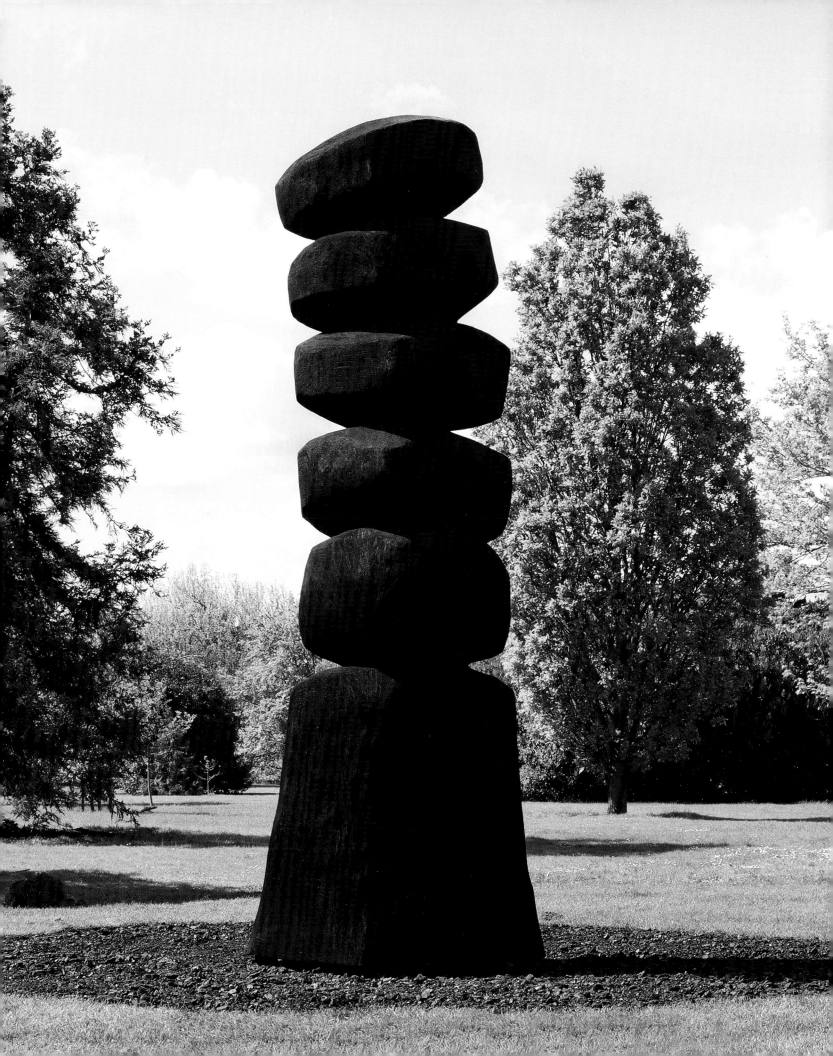

SHIRLEY SHERWOOD
GALLERY OF
BOTANICAL ART

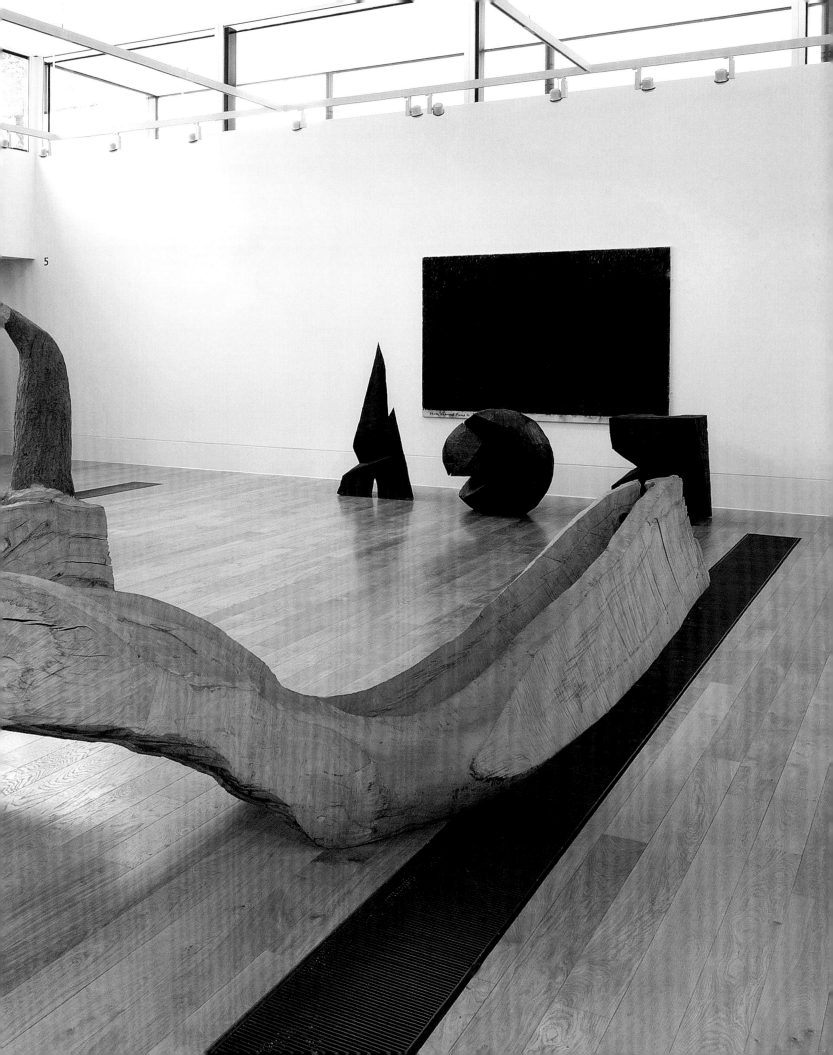

SCULPTURES IN THE GALLERY

These works range from the early 1980s to the early 2000s and illustrate many of Nash's recurring forms and themes. Tables, vessels, cubes and columns are seen in *Platter and Bowl* (1988), *Serpentine Vessels* (1989), *Cracking Box* (1990), *Light in the Shadows* (1993/4) and *Coil* (2001). A sense of fun and surrealism prevail in some works, for instance *Useful Pig* (1982) and *Two Ubus* (1988), while others continue his exploration of symbolic, emblematic shapes: the egg in *Palm Egg* (1995) and the geometric universal forms of cube, sphere pyramid in *Three Forms, Three Cuts* (1991).

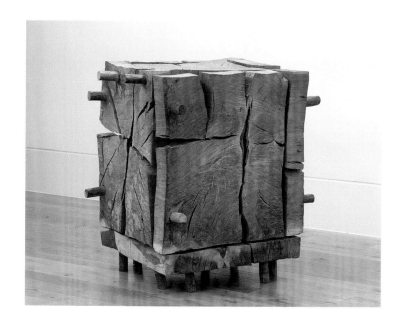

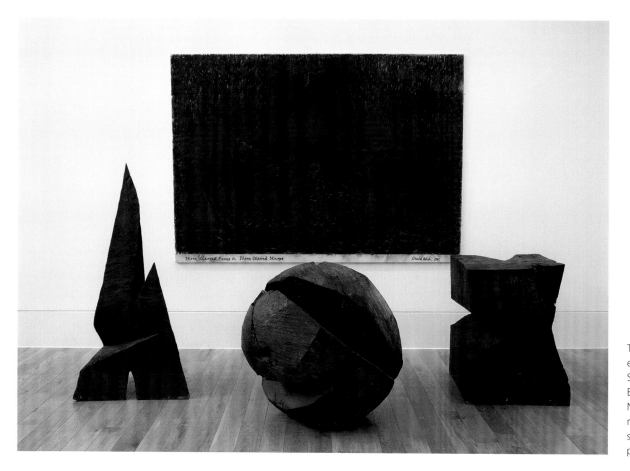

Throughout the Kew exhibition the Shirley Sherwood Gallery of Botanical Art will display Nash's works across a range of media: from wood sculptures to drawings, photographs and film.

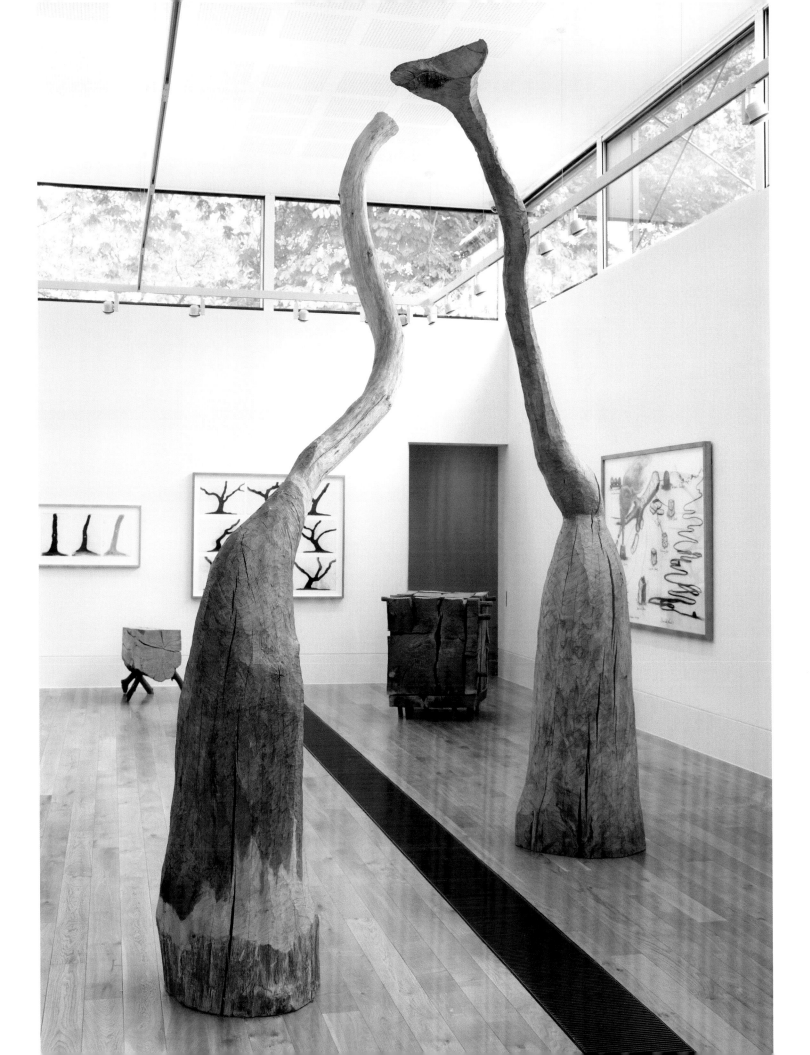

KEW TREE STUDIES

In the early spring of 2012 Nash produced a sequence of drawings depicting Kew trees including a Caucasian lime, sweet chestnut, chestnut-leaved oak, weeping beech and Norway maple. These beautifully simple charcoal works capture the essence of the trees and surrounding space.

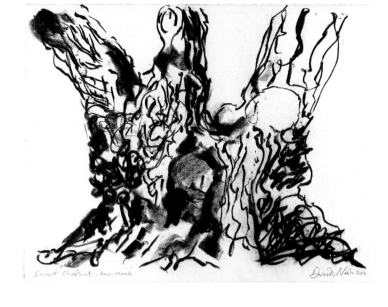

Sweet chestnut (2012), charcoal on paper.

Norway maple and Caucasian lime (2012), charcoal on paper.

Right: *Chestnut-leaved oak* (2012), charcoal on paper.

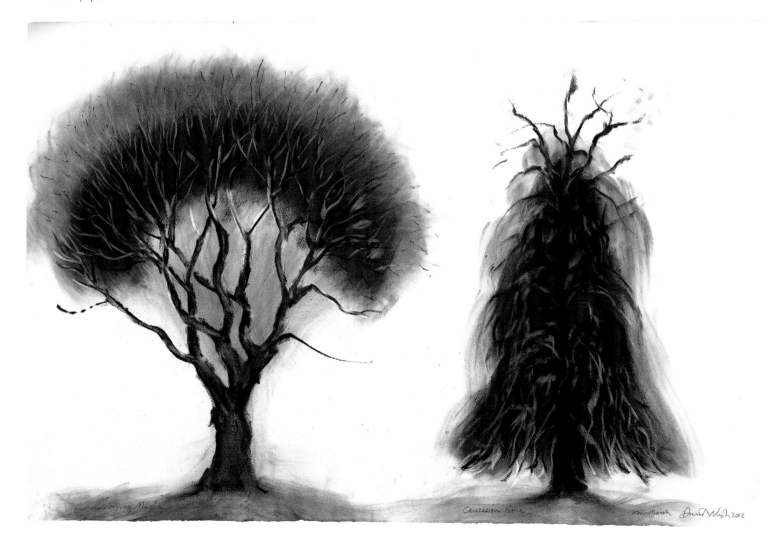

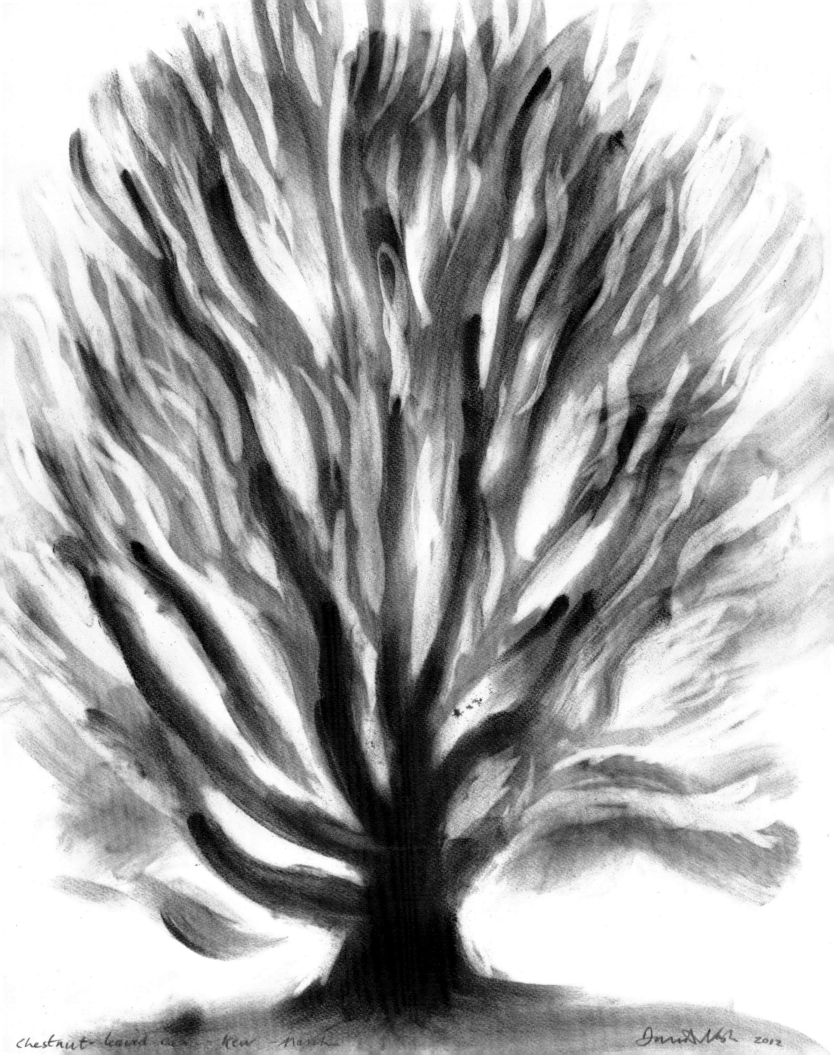

chestnut-leaved oak - Kew March David W. 2012

CAE'N-Y-COED

In the early 1970s five acres of wooded hillside in the Ffestiniog Valley were felled; the oak, ash and beech trunks were removed and the branches left behind. Nash helped the owner by clearing the land, gaining in return a ready source of material for his art, and he replenished the wood by planting trees. Later he came to own this land, which has now developed into an experimental outdoor laboratory, where he trials his ideas for 'Growing' projects. The images here and on the following pages show just a sample of these long-term projects, represented in exhibitions through drawings and film.

Leaning Larches, planted 1983, photo 2008.

'In the early 1970s, the question I had for outside sculpture was how to make it genuinely integrated with its environment. Most outdoor sculptures are made to resist the elements, made somewhere else and then taken to the site and usually placed on a plinth.'

David Nash

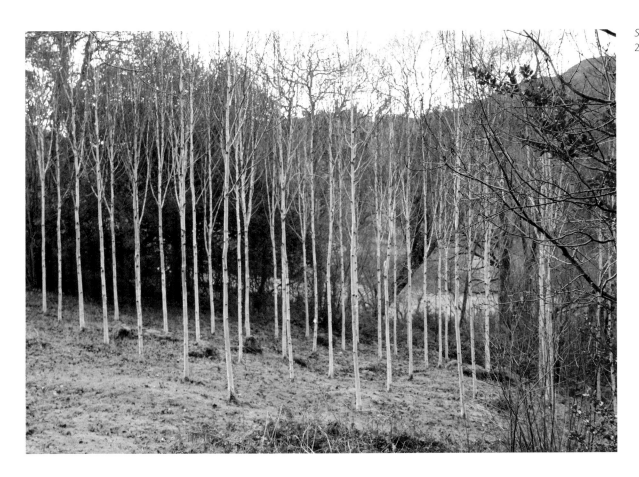

Seven by Seven, planted
2000, photo 2012.

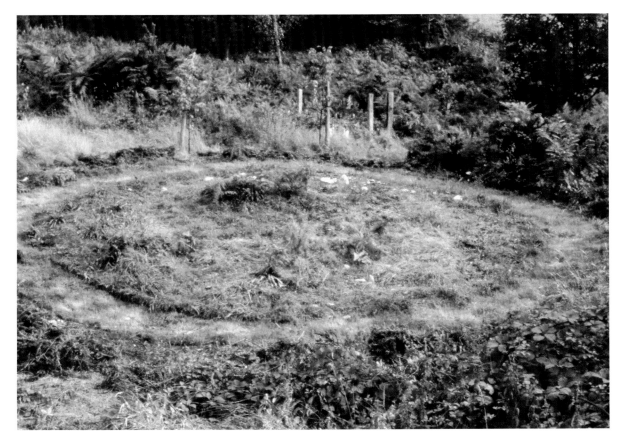

Sod Swap,
transplanting 1983.

BLUE RING

Blue Ring explores Nash's recognition of blue's transient quality and its resistance to being held in fixed form.

During the winter of 1983 Nash moved thousands of bluebell bulbs to form a 30 metre ring on an open slope of Cae'n-y-coed. When the bluebells flowered in the spring the circle was faintly discernible from the distance for a few brief weeks. After four years the form had dispersed back into a general sea of blue.

To present the work, Nash harvested sufficient deep-indigo seeds to scatter in a loose circle on a flat surface, displayed beneath a blue ring on canvas.

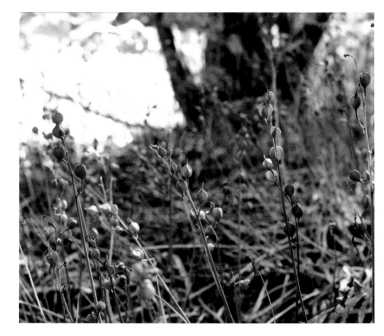

Each bluebell seedpod contains tiny intensely-indigo seeds.

The ring of blue on the Cae'n-y-coed hillside.

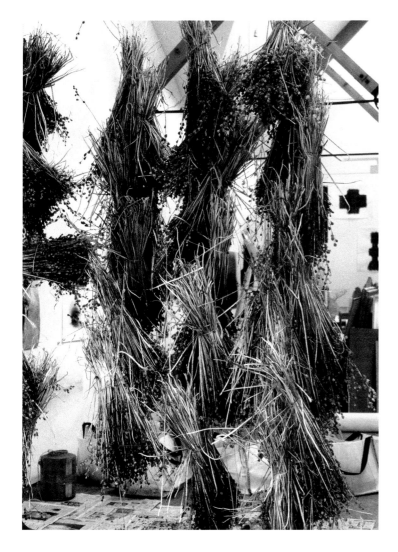

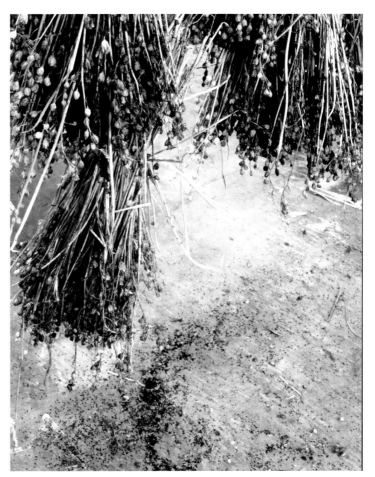

The harvested flowers hanging from the ceiling of Nash's drawing studio.

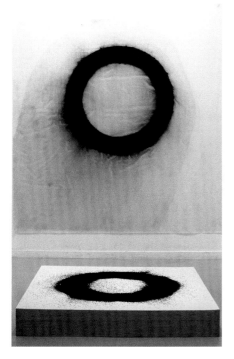

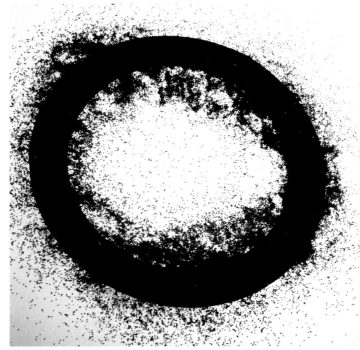

The ring of seeds and accompanying wall work.

ASH DOME

Ash Dome comprises 22 ash trees planted in a ring in 1977, and grown and trained to form a domed space. *Ash Dome* has now been growing into itself for over 30 years, turning the original artistic concept into reality. In uncertain times, this long-term thinking was both an act of faith and a commitment to the future.

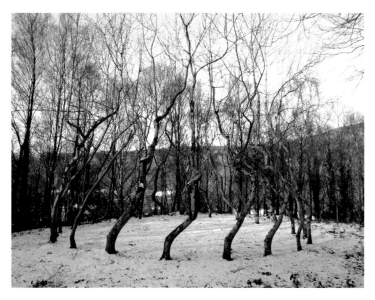

Ash Dome,
January 2009.

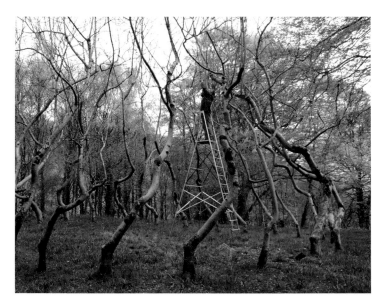

Pruning *Ash Dome*,
April 2009.

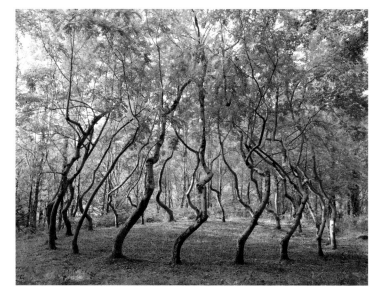

Ash Dome,
September 2009.

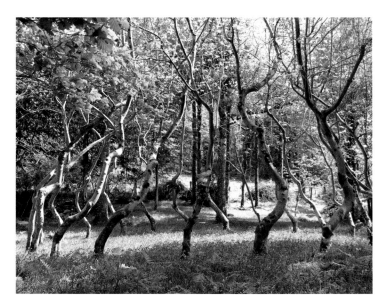

Ash Dome in spring,
May 2011.

'I am guiding the trees in the manner of the ancient Chinese potters who keep their minds on the invisible volume of space inside their pot and worked the clay up and around the shape of that space.'

David Nash

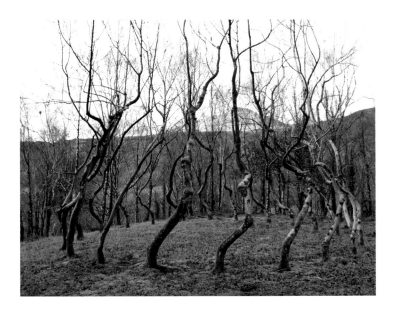

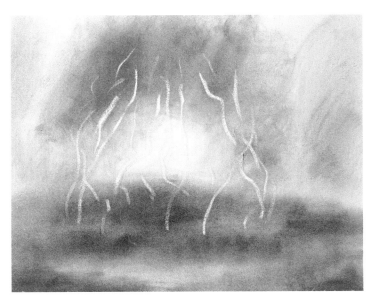

Ash Dome, January 2012.

The development and changing form of *Ash Dome* is recorded in series of pastel works and photographs.

WOODEN BOULDER

Wooden Boulder was carved from the first whole tree Nash had the opportunity to work with – a 250 year-old-oak growing on a Ffestiniog Valley hillside, and felled in 1978 after suffering storm damage. From the trunk, Nash carved a large rough sphere weighing 400 kg. As it would have been unsafe to transport this down the hill by footpath, he floated it in the stream.

The boulder jammed, halfway down the first waterfall. Impossible to retrieve or move, Nash began to document its changes through the seasons. The boulder turned deep indigo due to the tannins in the oak reacting with the iron in the water. Eventually it was dislodged by a storm, only to roll into another immovable position in the pool below, where it remained for eight years.

Over the years, *Wooden Boulder* has been moved downstream by storms nine times. Once it reached the River Dwyryd it floated up and down the estuary, moved by the wind, rain and tides. In 2003 it disappeared and there were no further sightings until 2008. It has not been seen since, raising the possibility it has finally journeyed into the sea.

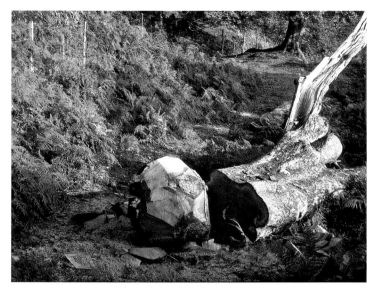

Wooden Boulder, at time of carving in September 1978.

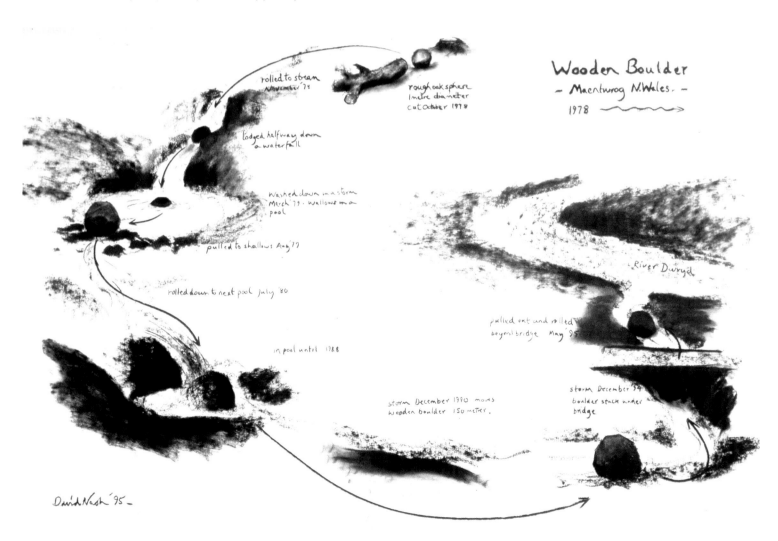

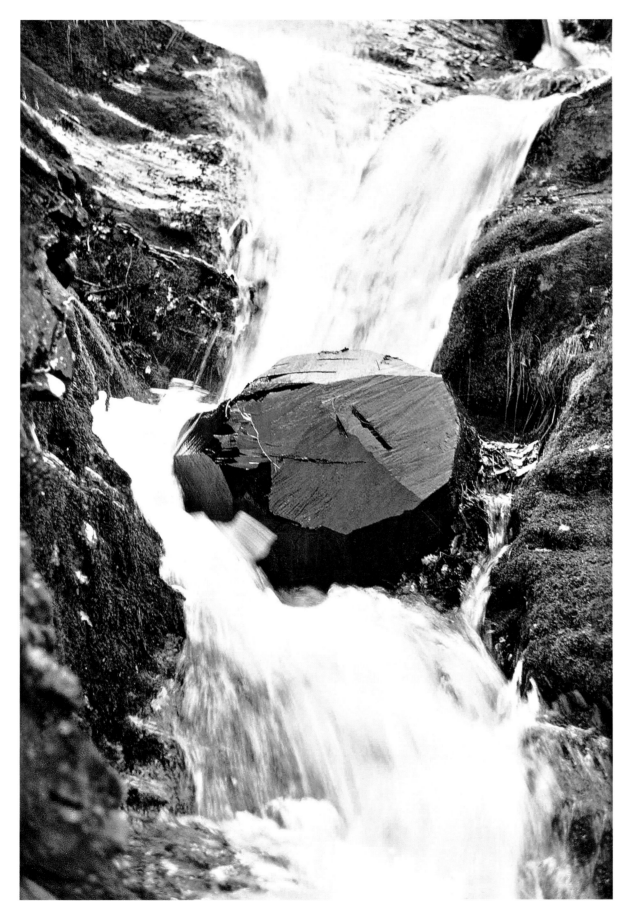

Wooden Boulder, wedged in a waterfall.

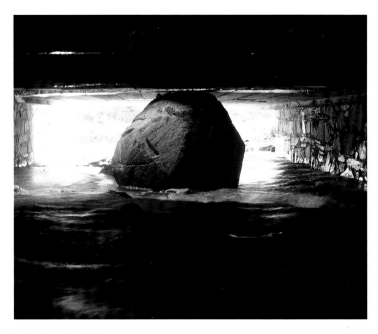

Lodged under a bridge,
1994.

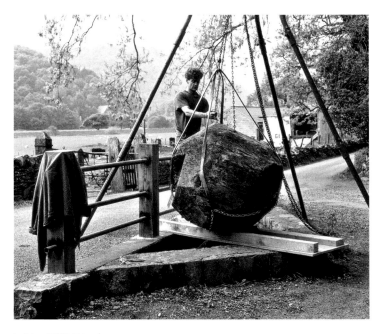

In May 1995 *Wooden
Boulder* was rescued from
under the bridge and freed
to continue its journey.

Wooden Boulder in 1998.

Wooden Boulder under a railway bridge, 2003.

Wooden Boulder, floating towards the Irish Sea in 2003.

DAVID NASH'S LIFE AND WORK

1945

Born in Esher, Surrey, England. Regular holidays in Ffestiniog, North Wales.

1963–64

Completes Foundation Diploma in Art and Design at Kingston College of Art.

Visits Brancusi's studio in Paris.

1964–67

Studies painting at Brighton College of Art before returning to Kingston to focus on sculpture.

1967

Revisits Brancusi's Paris studio. Moves to Blaenau Ffestiniog, North Wales.

Starts producing first major works, including *First Tower*, later blown down by high winds.

1968

Purchases Capel Rhiw and adjacent schoolhouse. Works for Economic Forestry Group and teaches art evening classes.

1969

Postgraduate studies at Chelsea School of Art, London, where he builds *Chelsea Towers I, II* and *III*.

1970

Returns to Wales, where he builds *The Waterfall* and his first carved works.

1971

Begins working on Cae'n-y-Coed woodland.

1972

Marries fellow artist Claire Langdown.

1973

Visits Paris and returns to Brancusi's studio.

Holds first solo exhibition, *Briefly Cooked Apples*, at the York Festival.

Son William born.

1975

Condition of Sculpture exhibition at the Hayward Gallery, London.

Receives major bursary from the Welsh Arts Council.

1977

Plants *Ash Dome* in Cae'n-y-Coed woodland, during March.

Begins working with chainsaw.

Son Jack born.

1978

Sculptor in residence at Grizedale Forest, Cumbria.

Wooden Boulder carved and rolled into stream.

1980

Exhibits in group show *British Arts Now* at the Guggenheim Museum, New York.

Exhibits in Venice, Glasgow and Rotterdam.

1981

Yorkshire Sculpture Park Fellowship, from September until January 1982.

Pyramids and Catapult: 20 days with an Elm shown in Leeds.

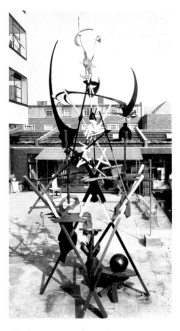

Chelsea Tower I (1969).

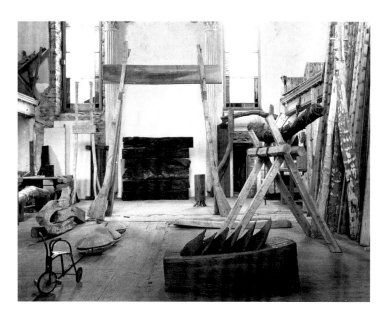

Capel Rhiw interior in 1976.

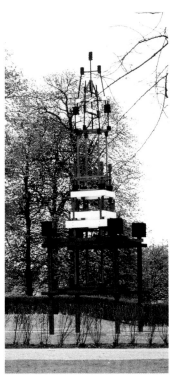

Chelsea Tower III (1970).

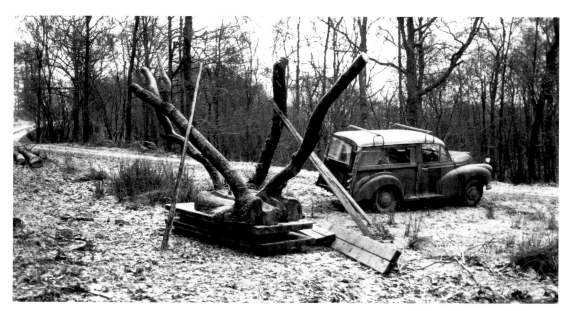

Grizedale Forest,
Cumbria, 1978.

1982

Many international exhibitions and projects including:

Twenty days with a Mizunara project in Kotoku, Upper Nikko province, Japan.

Resulting works shown in touring exhibition *Aspects of British Art Today.*

Wood Quarry at Kröller-Müller Museum, Otterlo, The Netherlands.

Yorkshire Sculpture Park Fellowship exhibition.

1983

Tate Gallery, London, purchases *Flying Frame.*

Sod Swap, Hyde Park and Cae'n-y-Coed on display at Serpentine Gallery, London.

First fletch on *Ash Dome.*

1984

Plants *Blue Ring.*

With family, travels to Japan from September to December. Several works made and exhibited.

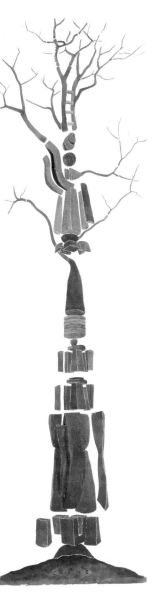

1985

International projects and exhibitions, including in the USA, Netherlands, Australia and Japan.

1986

Creates *Black Dome* in the Forest of Dean, as part of a sculpture trail.

1987

Exhibits in the USA touring show *A Quiet Revolution, British Sculpture since 1965.*

First solo show at LA Louver, Los Angeles.

1988

Exhibitions and projects in Scotland, France and Japan.

Stoves and Hearths film for Channel 4 television.

Watercolour illustrating the relationship of the oak sculptures to the original tree, from the *Chêne et Frêne* wood quarry and exhibition at Tournus Abbey in France, 1988.

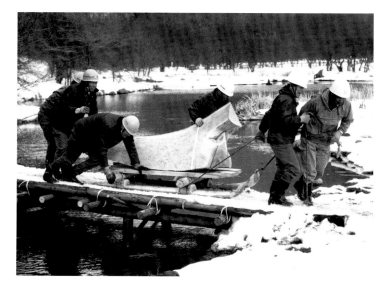

Transporting sculptures by snow sledge, Japan,1982.

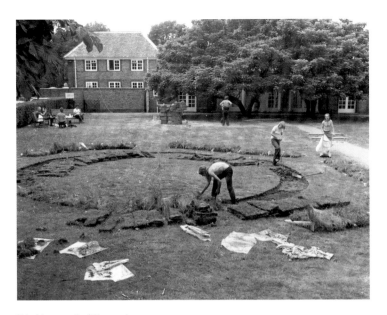

Working on *Sod Swap* at
the Serpentine Gallery,
London, 1983.

Nash's drawing studio in
2011 – the artist turned
a derelict shop into this
studio space in 1991.

1989

Project and exhibition at
Ile de Vassivière, France.

Beech project at Ashton
Court, Bristol.

First works using redwood
made in California, including
Strong Box and *Red Throne*.

1990

Solo exhibition at the Serpentine
Gallery, London, later tours to
Cardiff and Edinburgh.

Exhibitions at Louver Gallery,
New York, and in Paris and
Amsterdam.

1991

Converts a derelict shop near
Capel Rhiw into a drawing studio.

Wood Quarry project and
exhibition, Mappin Art
Gallery, Sheffield.

Walily project at Radunin, Poland,
and associated exhibitions.

1992–93

The Planted Projects, Louver
Gallery, New York.

Exhibitions in Manchester,
London and Denmark.

Work in northern
Hokkaido, Japan.

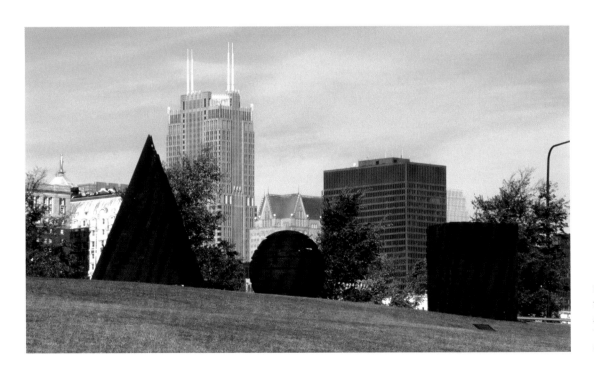

Universal forms set against
the Chicago cityscape.
*Pyramids Rise, Spheres
Turn and Cubes Stand Still*,
charred oak (2000).

1994

Otoineppu Spirit of Three Seasons touring exhibition, Japan.

Voyages and Vessels touring exhibition, Joslyn Art Museum, Nebraska, USA.

Nagoya commission *Descending Vessel.*

1995

Projects in Hawaii and California.

Més Enllà del Bosc project in Barcelona. Exhibitions in Barcelona and Palma de Mallorca, Spain.

1996–97

Exhibitions in the UK, Belgium, Germany and San Francisco.

David Nash – Language of Wood, PYO Gallery, Seoul.

1998

Exhibits in Luxembourg, Sweden, Los Angeles and New York.

1999

Elected Royal Academician.

Appointed Research Fellow at the University of Northumbria, Newcastle.

Awarded Honorary Doctorate in Art and Design by Kingston University.

2000

Exhibitions in Paris, Cardiff, Switzerland and Chicago.

Green and Black exhibition opens, Oriel 31, Newtown, Wales.

2001–02

Exhibits in Tokyo, London, New York and Cologne.

2003–04

Solo exhibitions in Berlin, Germany and Tate St Ives, UK.

Awarded OBE for services to the arts.

2005–06

Exhibitions in Spain, UK, USA, Switzerland, Sweden and Germany.

2007–09

Exhibitions in UK, USA, Korea, Spain and a museum-touring show in Germany.

2010–11

Solo retrospective exhibition at Yorkshire Sculpture Park.

Chapel floor reinforced to bear the weight of the sculpture collection.

2012–13

David Nash at Kew: A Natural Gallery opens at the Royal Botanic Gardens, Kew.

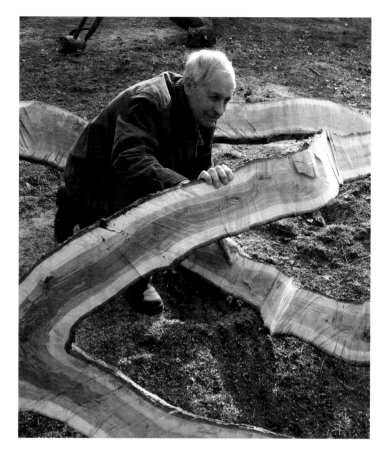

Splitting oak branches in the wood quarry at Kew, April 2012.

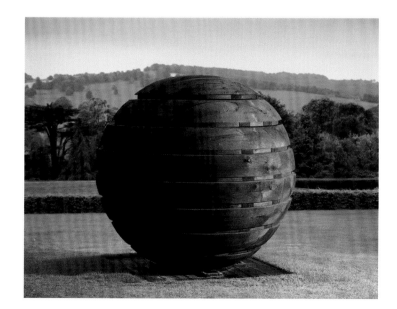

Black Sphere on display at Yorkshire Sculpture Park, 2010.

SOURCES AND FURTHER READING

Andrew, J. (1999): *The Sculpture of David Nash*, Lund Humphries, London.

Barker, I. (2005): *Pyramids Rise, Spheres Turn and Cubes Stand Still*, Annely Juda Fine Art, London.

Collins, J. (2001): *Black and Light*, Annely Juda Fine Art, London.

Deakin, R. (2008): 'David Nash' in *Wild Wood: A Journey Through Trees*, Penguin, London.

Lynton, N. (2007): *David Nash*, Thames and Hudson, London.

Mabey, R. (1999): 'David Nash's Artistic Estate' in *Selected Writings, 1974–1999*, Chatto & Windus, London.

Nash, D., Proulx, A., Murray, P. (2010): *David Nash at Yorkshire Sculpture Park*, Yorkshire Sculpture Park, Yorkshire.

Nash, D., and Warner, M. (2001): *Forms into Time*, Artmedia Press, London.

Nash, D., Daniel-McElroy, S., and Cork, R. (2004): *Making and Placing: Abstract Sculpture 1978–2004*, Tate St Ives.

Pheby, H. (2010): *David Nash at Yorkshire Sculpture Park: Exhibition Guide*, Yorkshire Sculpture Park, Yorkshire.

IPAD EDITION

Download the souvenir book iPad edition for added interactive features and exclusive interviews. Find it in the App Store.

ACKNOWLEDGEMENTS

The Board of Trustees of the Royal Botanic Gardens, Kew would like to thank:

David Nash for his enormous energy and commitment in making this project a reality.

Xstrata plc for their generous support of the exhibition.

Dr Shirley Sherwood, Laura Giuffrida and The Shirley Sherwood Gallery of Botanical Art for their support of the exhibition.

Mark Jacobs, Sam Clayton, Alan Smith, Annely Juda Fine Art, Galerie Scheffel, Mtec, Castle Fine Arts Foundry, Wales, and Kunstguss Eschenburg Lahn-Dill GmbH, Germany.

Tony Kirkham and the Arboretum team; Dave Cooke and the Temperate House team; Lara Jewitt and the Princess of Wales Conservatory team, and Dave Davies, Dave Burns and Charles Shine from the Hardy Display team for their ongoing support and assistance.

Tom Cullen, Julie Bowers and Valetta O'Callaghan from the Kew Estates department for their ongoing support and assistance.

Kew photographers Andrew McRobb and Paul Little for the exhibition photography.

Project Manager Ann Lawlor for her ongoing dedication and hard work.

PHOTOGRAPHY CREDITS

Cover and outside flaps photography © Jeff Eden; p4 Andrew McRobb; p6 Paul Little; p9–11 © David Nash; p12–13 © David Nash, courtesy Galerie Scheffel, Germany; p14 © Jonty Wilde, courtesy David Nash/Yorkshire Sculpture Park; p15 top left: © Jonty Wilde, courtesy David Nash/Yorkshire Sculpture Park; p15–17 © David Nash, courtesy Galerie Scheffel; p18 left: Paul Little, right: Andrew McRobb; p19 left: © David Nash, right: Andrew McRobb; p20–24 Andrew McRobb; p25 left: © David Nash, right: Paul Little; p26–30 Andrew McRobb; p31 top left and right: © David Nash, bottom: Andrew McRobb; p32–33 © Jonty Wilde, courtesy David Nash/Yorkshire Sculpture Park; p34 © David Nash, courtesy Galerie Scheffel, Germany; p35 © David Nash; p36 Andrew McRobb; p37 Paul Little; p38 Paul Little; p40–43 © David Nash; p44–45 © David Nash, courtesy Galerie Scheffel, Germany; p47 © David Nash; p46 Andrew McRobb; p48–50 © David Nash; p51 Andrew McRobb; p52 © David Nash; p53 Andrew McRobb; p54 © David Nash; p55 © David Nash, courtesy Galerie Scheffel, Germany; p56 top and left: © David Nash; p56 right and p57: © Tony West, courtesy of Blackwell House; p58 © David Nash; p59 Andrew McRobb; p60 Andrew McRobb; p61 top: © David Nash, bottom: Andrew McRobb; p62 Andrew McRobb; p63 Andrew McRobb; p64 © David Nash; p65 Andrew McRobb; p66 Andrew McRobb; p67 © David Nash; p68 © David Nash; p69 © Jeff Eden; p70 Andrew McRobb; p71 left: Andrew McRobb, top and bottom right: ©David Nash; p72 © David Nash; p73–77 Andrew McRobb; p78–79 Paul Little; p80–85 © David Nash; p85 top right: © David Nash, courtesy Galerie Scheffel, Germany; p86 top right: © David Nash, courtesy Galerie Scheffel, Germany, bottom © David Nash; p87 © David Nash, courtesy Galerie Scheffel, Germany; p88 top left: © David Nash; p88 top right and bottom: © David Nash, courtesy Galerie Scheffel, Germany; p89 © David Nash, courtesy Galerie Scheffel, Germany; p90–92 © David Nash; p93 top: Paul Little, bottom: © Jonty Wilde, courtesy David Nash/Yorkshire Sculpture Park; p94 © Jeff Eden; inside back cover: Paul Little.